Painting
Water

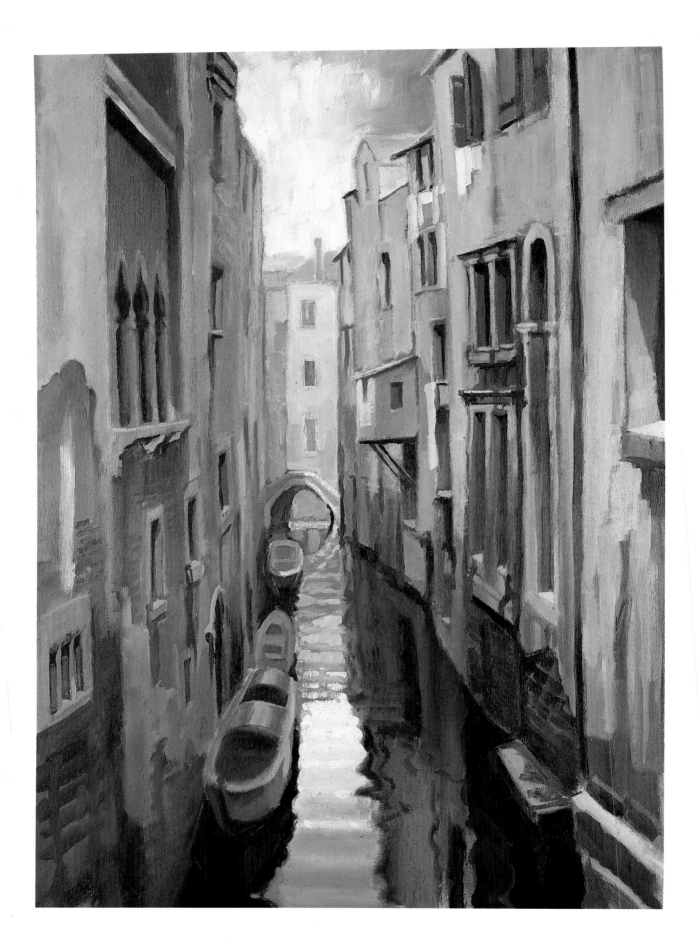

WATERCOLOUR BASICS

Painting
Water

Michael B. Edwards

David & Charles

About the Author

Michael B. Edwards was born on the east coast of England in a small Essex village, and now lives in Gloucestershire. He exhibits regularly in watercolour, acrylics and oils, and is the author of *Painting Towns and Cities*. He particularly enjoys painting marine and waterside subjects, and the surrounding harbours and ports. He is also a keen yachtsman – the owner of a 35ft yacht *Klondike Kate* – and a member of the Royal Western Yacht Club.

For Karen and Sarita

ACKNOWLEDGEMENTS

I am greatly indebted to the guest artists whose work appears in various chapters and in the Gallery at the end. Their paintings add much variety and style to the book. I would also like to thank Alison Elks as editor for her continued support and helpful guidance, Unicorn Services for typing the manuscript and Brian Middlehurst for photographing many of the paintings.

The owners of the paintings reproduced in the book are thanked for their permission to reproduce the works.

Page 2: *Venice* Oil, 36×24in (91.5×61cm).

A DAVID & CHARLES BOOK

Copyright © Michael Edwards 1993, 1995
First published 1993 as *Painting Waterside Landscapes*
This paperback edition first published 1995

A catalogue record for this book is available from the British Library.

ISBN 0 7153 0363 5 (paperback)
ISBN 0 7153 0427 5 (hardback)

Typeset by ABM Typographics Ltd
and printed in Hong Kong
by Wing King Tong Co. Ltd
for David & Charles
Brunel House Newton Abbot Devon

Contents

Introduction

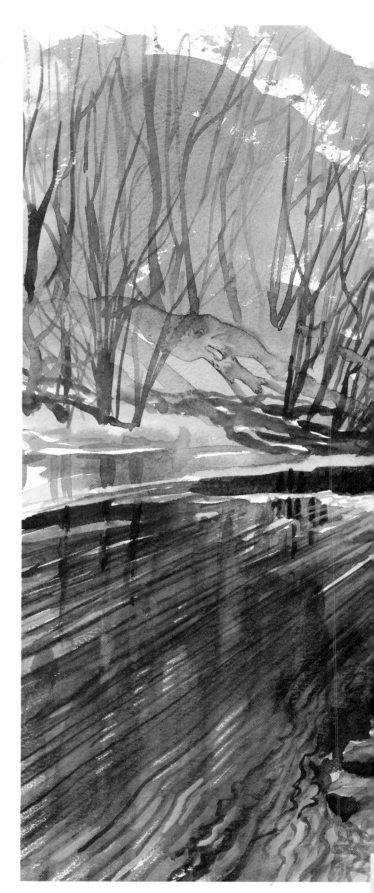

Many of the best-loved pictures in galleries around the world are waterside landscapes. Water as a subject has always had a fascination for artists such as Monet contemplating his lily pond at Giverney or Constable capturing on canvas the haywain at Flatford Mill.

The joy for the painter is often unsurpassed when sitting by a mountain river, overlooking a beautiful landscape of colour, light and tone. The waterside can also provide action and drama with roaring surf crashing on to rocks and cliffs, and the racing yachtsman struggling to control his pitching craft in a stormy sea. What diversity and scope exists for the waterside painter and what challenges in capturing light, action, mood and atmosphere.

Mountain River in Spring
Watercolour, 16 × 20in (41 × 51cm).
Spring sunshine casts shadows through the trees, with winter colours still present in the woods, banks and water. A riverside has an abundance of subjects for waterside landscapes.

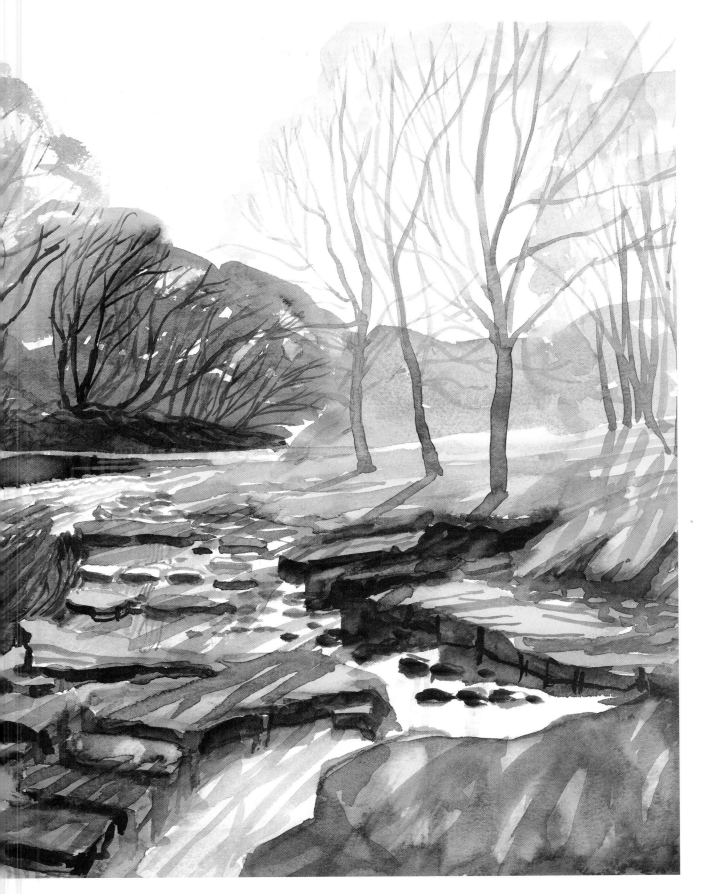

In this book I have set out to provide a comprehensive coverage of painting waterside landscapes from still water through to ripples and waves and on to surf breaking on cliffs and rocks. To complement the painting of the sea the essential supporting subjects of harbours, boats and yachts, rocks, cliffs and beach scenes are included. To complement rivers and lakes there are various types of landscape backgrounds including mountains, woods, and waterside cities, together with anglers, waterfalls, and various types of bridges. I have also included the closely associated subject of painting skies. To back up these topics such things as materials and equipment, techniques and style are covered. Although not designed for the absolute beginner, this book nevertheless takes the reader from simple washes for still water to complex harbour scenes.

You will see when scanning the pages that the visual content is high. I personally flip through new painting books looking at the pictures and reading captions before reaching the text; often the greatest rewards come from studying the paintings to gain ideas and inspiration.

The medium involved in this book is mainly water-colour, but with examples of oils, acrylics, pen drawings and gouache. Hopefully you might be encouraged to try alternative media and styles which, even if not leading to a permanent change, will provide new ideas and approaches for your work.

Likewise I have included a number of guest artists with an international flavour to widen the coverage and provide different ideas and inspiration. Stage-by-stage illustrations are targeted at key subjects: still water, reflections, running water, and cloudy skies, together with a reference materials section covering sketchbook work and photographs.

View from Waterloo Bridge
Acrylic, 18×24in (46×61cm).
Dramatic views of famous cities can often be found with a river in the foreground. Monet painted several famous views of London, including one from Waterloo Bridge on a foggy day.

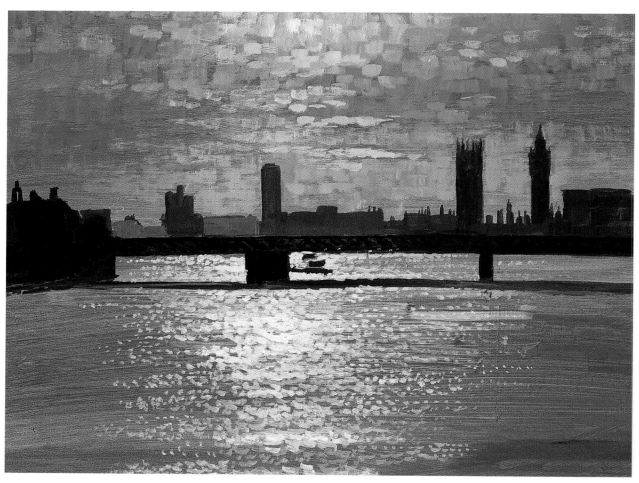

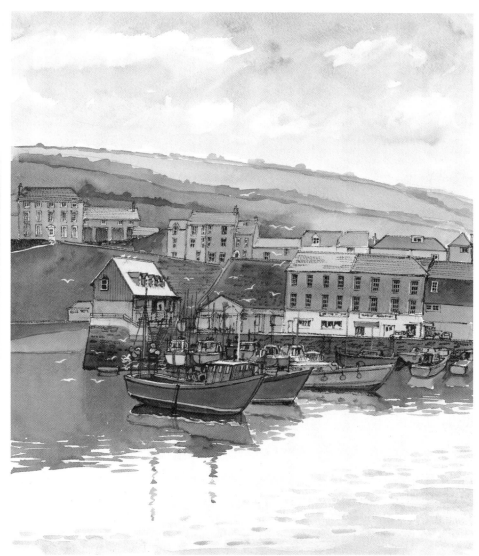

Mevagissey, Cornwall
Pen and Wash,
20×61in (51×41cm).
*Harbours have endless
material for the artist
whether in a quiet English
fishing village such as
Mevagissey or a mighty
commercial city and port
such as New York.*

AN EARLY INTEREST

My own fascination with the waterside started in early childhood on the coasts of eastern England. Those cold windswept winters on the Essex marshes or on the open shores of Norfolk and Suffolk still linger as visual memories with acute clearness.

The East Anglian painters of the past – Constable, Cotman, Crome – all included waterscapes in their repertoire with outstanding examples in watercolours and oils. More recently Edward Seago has inspired many with his Norfolk coastal landscapes.

My childhood also introduced me to the pleasures of sailing and now this has been combined with painting not only in English ports and harbours but also overseas in France and Ireland as well. There is nothing I enjoy more than watching the sunset in a beautiful harbour,

Fishing boat, Massachusetts
(Sketch).

sketchbook in hand, whisky close by, from the deck of my yacht *Klondike Kate*.

When not on the coast, but in the countryside or city, I am still drawn to water, which adds that extra sparkle to my paintings. A wet street reflecting lights in the city centre, or the sparkle of tumbling water in a mountain stream, create an extra dimension.

When trying to analyse the principal attraction of painting waterside landscapes there are many facets which appeal but above all it is the light – water introduces light, and with light comes atmosphere. The painting below of boys fishing on a summer's day epitomises water's attractions. Sparkling light on gently moving water with the liquid reflection of the boat and its occupants creates an image of a lazy summer's day with the background haze emphasising the misty heat.

The waterside also has the connotations of action, activity and excitement with water-based pursuits such as windsurfing, sailing and water-skiing, not forgetting the activities of those whose livelihood depends on the sea, the fishermen. A busy fishing port, for example, is an exciting place to paint with the hustle and bustle of fishing boats leaving for far distant grounds and seagulls screeching overhead, echoing round the harbourside houses. To artists who sail, a yacht race can be a fascinat-

ing subject but it can be difficult to capture. Sketching on a racing yacht beating to windward in a near gale force 7 is not only difficult but to the rest of the crew, absolutely crazy. To capture such a scene one has to rely on memory, photographs or both.

WATERSCAPE PROBLEMS

What of the problems of painting waterside landscapes? To the beginner, perhaps, painting water is something to avoid – too complicated and best left to the expert. In reality, of course, it is no more difficult than most areas of painting and in relation to the benefits in terms of the liveliness and saleability of the resulting picture, it's a subject well worth mastering.

As with many areas of painting, water can be broken down into simplified elements. When you are looking at the complexities of waves and ripples in a busy harbour it is easy to say to yourself 'impossible', but by simplifying the wave forms and using broad and direct brush strokes you can often create order out of chaos. Although there is more to painting than technique alone, technical competence is necessary to enable you to express yourself fully in a chosen medium.

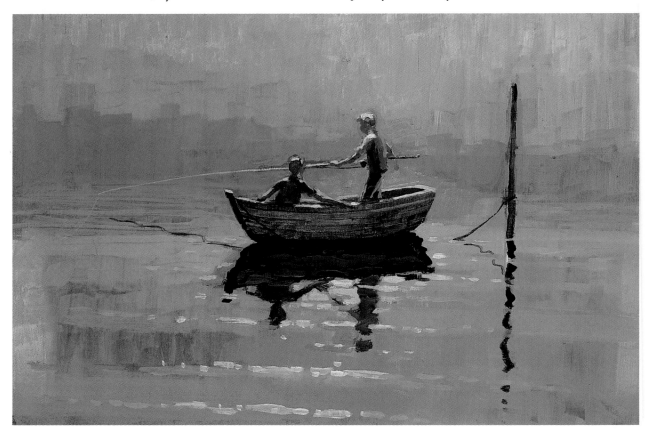

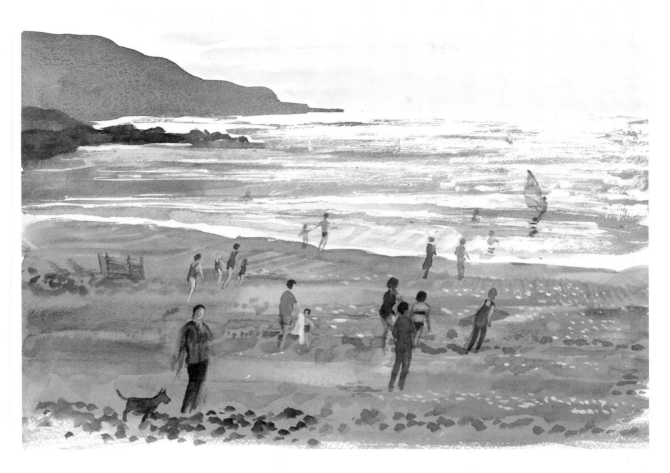

△ *On the Beach*
12×16in (30.5×41cm).
Beach scenes have an endless variety of subjects and backgrounds. This early season view has a coolness quite different from the hot bright colours to be seen in midsummer.

◁ *Gone Fishing*
Acrylic, 12×16in
(30.5×41cm).
The liquid qualities of waterside landscapes are often emphasised by reflections. The sun sparkling on the surface also provides an immediate feeling of water and a midsummer atmosphere.

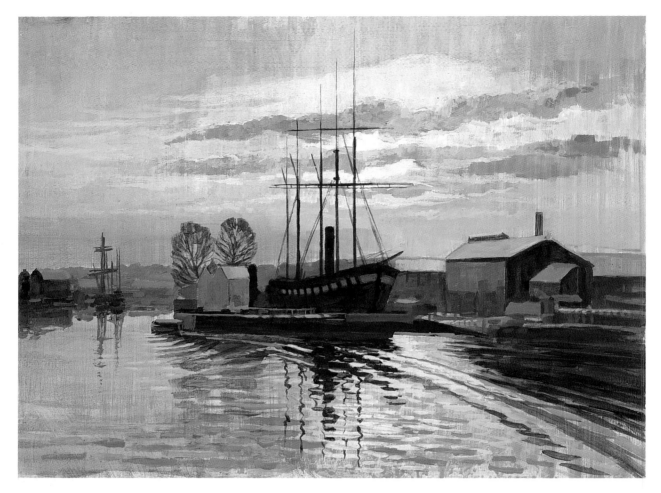

MARINE PAINTING

The painting of historic ships has developed into a sizable sector of marine painting with specialised artists who not only have a technical mastery of the details of ships they paint but also have considerable skill in depicting the sea in action. A favourite is the ocean storm, white tops on mountainous waves with a ship heeling to the wind and waves with its sails in shreds. Although I have not pursued this area in any depth, I have occasionally encountered a tall ship in a dry dock or in the Tall Ships' Race which makes a fascinating subject.

Close to my studio in Bristol is such a ship, the *SS Great Britain* – the world's first screw-driven metal ship. As shown above this is a delightful subject for a waterside landscape.

ATMOSPHERE

The waterside in every country has it own ambience and atmosphere. I have included paintings from my visits to

SS Gt Britain, Bristol Harbour
Acrylic, 18×24in (46×61cm).
Tall ships make fascinating subjects for the marine painter. This famous old ship is now in the dry dock where she was built in 1843. Note how the ripples from the small boat have added interest to the water in the foreground.

USA, Canada, Switzerland, Italy and France to illustrate some obvious differences. Atmosphere and water are inevitably linked. Sunset over the harbour, a bright, sunny beach, mist over a mountain lake or snow around a freezing pond – you can probably bring to mind many such images from your own memory. Making your painting atmospheric will often differentiate it from many others. Compare the experienced or professional work with that of the amateur and you will find one of the most consistent differences is the atmosphere which pervades the professional work. This comes from choice of subject, colour, tones, light, composition and

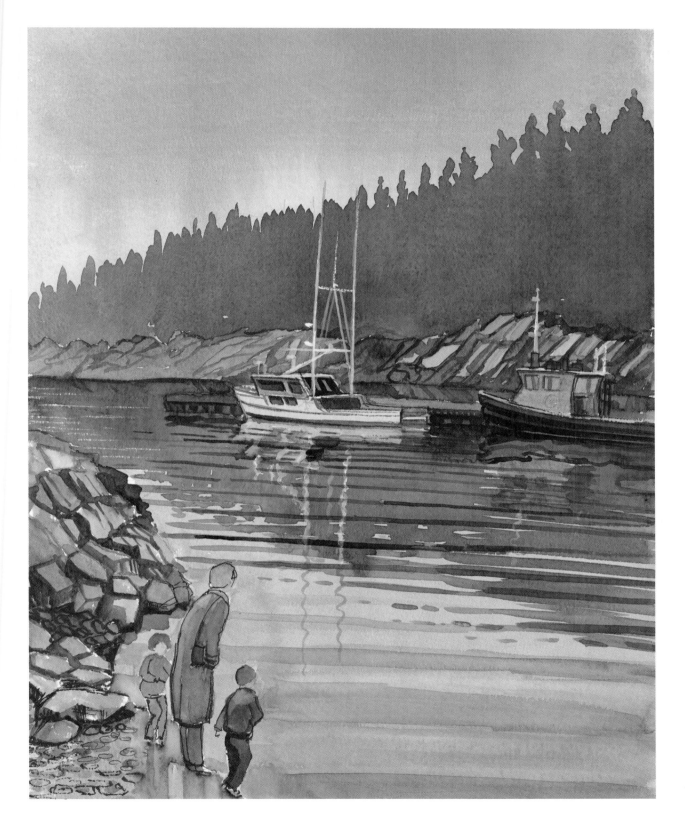

Fishing Boats at Lund, British Columbia
Watercolour, 18×14in (46×36cm).
The Canadian west coast has many small inlets and fishing villages. An area of outstanding natural beauty, it is a paradise for the painter of waterside landscapes.

13

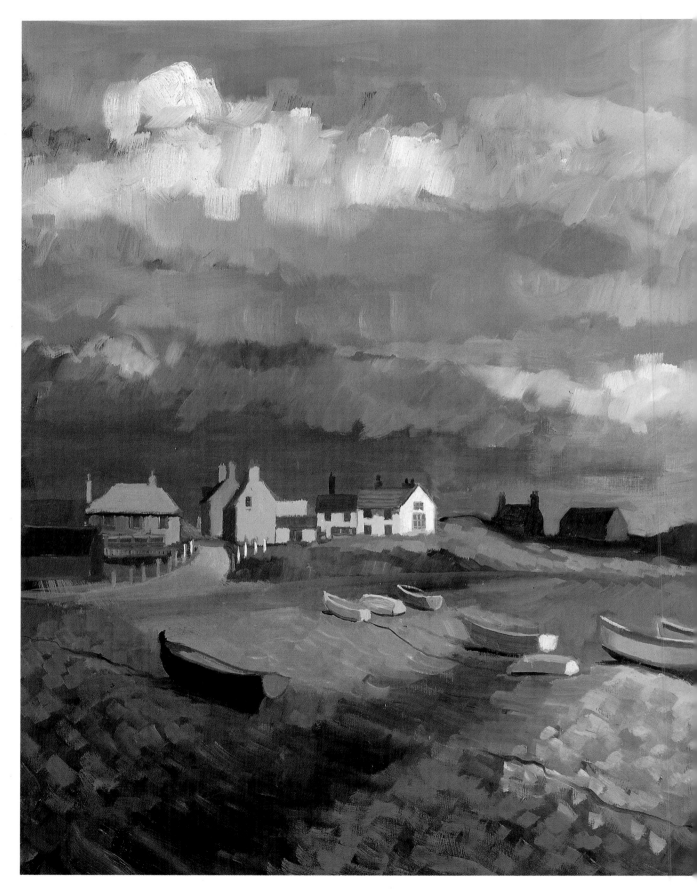

emphasis – all of which are used to create a picture which communicates the atmosphere of country, season or time of day.

Waterside landscapes do not always have to include water as is illustrated in the picture, left, of a Suffolk coastal scene. The atmosphere is entirely waterside with the flat landscape, boats on the foreshore, the storm passing from the sea inland and the houses clustered behind the dunes. While this scene is typical of East Anglia, each area of the coastline has its own special flavour. Equally the eastern seaboard of the United States, the west coast of British Columbia, the Great Barrier Reef of Australia and the Côte d'Azur of France all have their own unique characteristics and individuality.

I hope that this book helps you to capture the atmosphere and character of waterside landscapes.

Suffolk Coastline
Oil, 36✕36in (91.5✕91.5cm).
*Even when the sea is not present, the
shore has a unique waterside feel to it.
Based on a watercolour sketch on site,
this oil painting of the Suffolk coast was
painted to capture light patterns cast by
the passing storm clouds on an autumnal
day.*

1
Materials and Equipment

WATERCOLOUR

You can start to paint in watercolour with the most simple equipment: a paintbox, brush and paper. It soon becomes apparent, however, that better materials and equipment can help significantly in improving your results.

Paint varies greatly, from the cheaper-quality material which has limited durability and intensity, to the most expensive artist's colours which are long lasting, consistent in colour and have good qualities of flow. Paint also varies from manufacturer to manufacturer. Most leading manufacturers produce good quality paints but their character varies quite markedly. The colours will differ – for example, terre verte from one manufacturer may be a different colour from that of another – and the texture of the paint will vary according to how much gum or other additives have been included. There are advantages in getting to know one manufacturer's products quite well as it will enable you to understand how the paint will perform in your paintings.

Watercolour can be used in block form or in tubes. I personally use a small watercolour box for sketching but in the studio use tubes of colour and a large palette. Colours have differing properties when applied to paper. Some stain the paper and are hard to wash off. Some will flow evenly across a paper with a rough surface, others sink into the paper's roughness, making granulated effects. Some colours can be washed on to the paper and when dry other colours can be washed on top without disturbing the original, but not all will be as willing to accept subsequent washes.

Every artist develops a familiarity with certain paints, brushes and equipment which are often unvaried for years. My own approach is to be simple and straightforward with a low-cost bias.

With watercolour, particularly if you use extensive washes in your technique, it is valuable to practise washing different colours on to differing papers to check how they react. Control of tones (the degree of lightness or darkness in a colour) is entirely performed by greater or lesser dilution with water. Hence it is essential to use large pans or saucers for mixing the colours and to have lots of clean water to hand.

Brushes have a greater impact on the quality and style of watercolour painting. If you want to achieve fresh washes, with clear and consistent tones, then a large soft brush is essential. A large brush holds a sizable quantity of water, enabling you to make a large wash flow without recharging the brush. In this way you are less likely to accidentally vary tone and colour, a thing which often occurs when the brush is recharged with paint from the palette or box.

Brushes come in all shapes: pointed, flat, round, fan-like, narrow, long, short or fat. The best watercolour brushes are sable but they are prohibitively expensive. Synthetic brushes work well, as do mixed sable and synthetic, or ox-hair, camel- or squirrel-hair. Careful cleaning and storage of brushes will prolong their useful lives. For normal use a limited combination of pointed, flat and round brushes will suffice. I personally use a large pointed No20 for much of my watercolour work

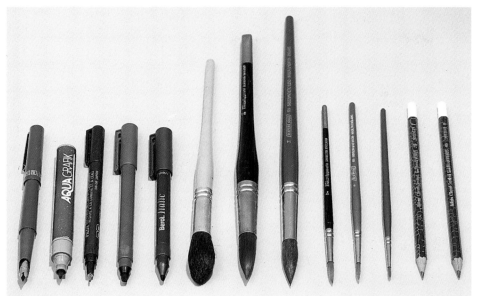

Brushes for watercolour vary in size and shape tremendously. The brushes used for this book are shown here ranging from a No 2 pointed to No 20, together with a range of marker pens, a technical drawing pen and an ink pen designed to use waterproof ink.

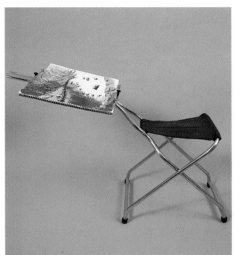
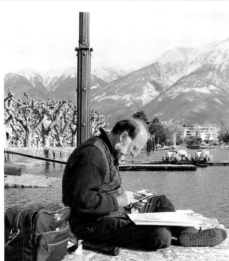

A combined stool/easel can be valuable for on-site painting but when a suitable place to sit is available, I prefer to paint with the sketchbook on my knees.

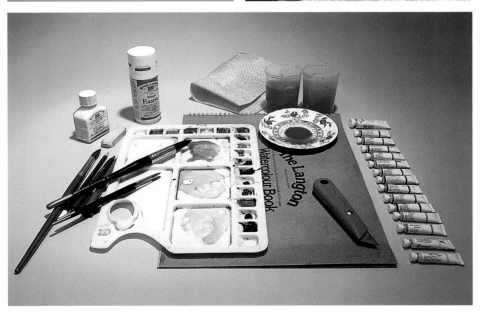

The studio equipment includes a large plastic palette with spaces to mix wet washes, fixative, masking fluid, a sharp razor knife to scratch highlights, and artists' colours in tubes including the following:- Venetian red, Winsor red, crimson, Van Dyke brown, raw umber, yellow ochre, cadmium yellow, chrome lemon, sap green, Hooker's green, cobalt blue, ultramarine, Davy's grey, Payne's grey and black.

with a No7 for finer work and a No2 for thin lines. In addition you will find a sponge or rag helpful to mop up very wet patches or to merge wet in wet edges.

Papers of all types of weight, surface and colour are available. A wet wash will buckle lighter papers unless they have been stretched. Stretching involves sticking down the edges of a thoroughly wet sheet of paper on to a drawing board and letting it dry. If you use a heavy weight of paper (140lb plus) buckling is less likely.

Papers come in various levels of roughness. Hot pressed paper (HP) has a hard, smooth surface very suitable for drawing in pen or pencil but not much favoured for painting. Cold pressed paper or 'not' – meaning not pressed – is a textured semi-rough paper, good for large smooth washes and a general purpose paper. Rough paper has a tooth which is quite strong and will show clearly in washes or dry brush work when the paint is dragged across the surface. The very best papers are handmade with a high linen rag content.

A material useful in watercolour painting is masking fluid. This liquid, when painted on to paper, produces a rubbery film, preventing subsequent colour washes from colouring the paper. When the painting is dry the film can be rubbed off leaving the original paper showing through. Examples are shown later, particularly in seascape painting.

Additives to the water used for painting watercolours include gum arabic to increase viscosity, oxgall liquid to improve flow and glycerine to inhibit fast drying, for example, in very hot climates. Equipment needed for painting outdoors include an easel, stool, bag and so forth. It is possible to obtain combined easels and stools which are very useful.

OILS AND ACRYLICS

The equipment necessary for both oils and acrylics has considerable overlap. You can use similar easels, paintbrushes and palettes, the fundamental difference being that acrylics use water and dry very fast, whereas oil paint uses linseed oil and turpentine and dries more slowly.

Acrylic and oil paints are supplied in tubes, the quality and cost of which vary considerably. Artist's quality is the best and the major manufacturers all produce durable paints, with consistent colour and good intensity. As in watercolour, the hues vary between manufacturers as does the viscosity and density of the paint as it leaves the tube. It is best to become accustomed to one manufacturer's paints and hence know the colours and how they handle. It is possible to obtain additives to speed up the drying or slow it down, and to increase the brilliance of the surface, or make it matt.

While it is possible to use soft sable-type brushes similar to those used for watercolour, many artists use stiff bristle brushes for oils and acrylics. It is valuable to experiment to see what suits the type of work you are doing. If there is much detailed fine line work then a sable-type pointed brush will be necessary. Acrylics in particular can be painted thinly in a similar way to watercolour. This being the case, watercolour-type brushes are most appropriate.

The material on which you can paint, such as canvas or board, is usually termed the support. Both oils and acrylics can be painted on suitably prepared supports ranging from linen or canvas to wooden boards. The preparation necessary varies according to the support

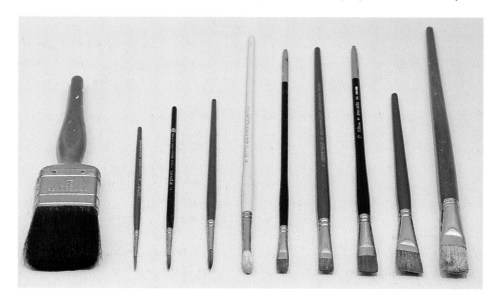

Similar brushes are often used for both oils and acrylics. I tend to use soft wedge-shaped brushes, rather than bristles (which are often used for oils). The decorator's brush is to apply priming and underpainting.

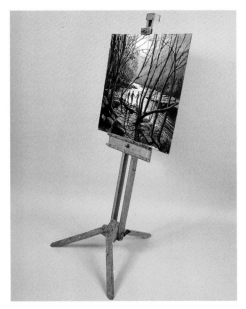

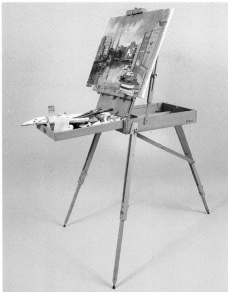

A combined box and easel is a valuable piece of equipment for painting outside with oils or acrylics and avoids having to carry separate bags, boxes and easels. In the studio (top left) *I use a standard radial easel which I find suitable to handle a wide range of sizes up to 48×48in (122×122cm).*

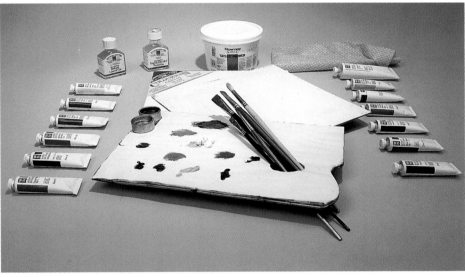

The oil-painting equipment is shown here, although similar equipment is used for acrylic apart from the turpentine and linseed oil. I use a paper palette inside and out for convenience and paint on ready stretched cotton canvas or on hardboard prepared with acrylic gesso.

and also the surface needed for the final painting. A glue size has traditionally been used for oil painting surfaces, but priming materials can be obtained from art stockists for either oil or acrylic. The surface texture of the support makes a significant difference to the final painting. A strongly textured finish will create a pattern in the final painting as paint will tend to stick on the high points of the surface and not in the troughs or valleys. Canvas can be obtained with varying textures, boards can be prepared using a thick priming, to form brush marks which create a surface texture on the board.

Other equipment needed will include a palette, dippers and rags. Palettes can be of wood or plastic; particularly useful on location are tear-off paper palettes. For studio work a heavyweight easel is re-

quired; either use a radial easel or larger studio easels which are available for extra-large-scale work. Outside I use a portable box easel which I have found to be very valuable as it combines easel and box into one convenient and mobile unit. If you keep brushes and equipment clean and well cared for, they will last for a long time. In the case of acrylics the paint dries very quickly and can rapidly ruin brushes. Keeping the brushes continually damp when in use helps to prolong their use, but I have found it almost impossible to stop acrylic brushes deteriorating steadily with use. Acrylic paints also dry quickly on the palette, although there are special palettes to keep the paint moist. Try to judge the amount of paint needed for each session and thus not waste too much due to quick drying on the palette.

2
Painting Water

STILL WATER

To paint still water is to create an illusion. Water in a glass vase is transparent to the artist who creates this illusion in a number of ways. It may be by painting the line of the surface of the water, or perhaps the distortion of flower stalks or background caused by the refraction of the water inside the vase. Similarly, in a landscape, water is often suggested by reflections, or for instance an apparent patch of light in the middle of a dark landscape. A range of mountains with a flat, dark strip at the base suggests a lake, a touch of blue in the middle of a green field suggests a river running through it.

The essential characteristic of still water is that it reflects, usually the sky and whatever is close to it in the landscape – trees, bridges, buildings or mountains. Often, therefore, painting still water is a painting of the landscape upside down. You will have seen photographs where it is difficult to tell which is reflection and which the real object. Unfortunately if you paint a perfect reflection it looks unreal. Water usually has movement, however slight, which will modify the reflected shapes.

Winter Stillness
Watercolour, 14×18in (36×46cm).
Still water has a mirror-like quality reflecting the light in the sky and providing a quiet peacefulness to any landscape. In this snow scene simple washes provide delicate colours for sky and water. The tree is used to balance the composition, the colours being limited to Van Dyke brown, Payne's grey, cobalt blue and yellow ochre.

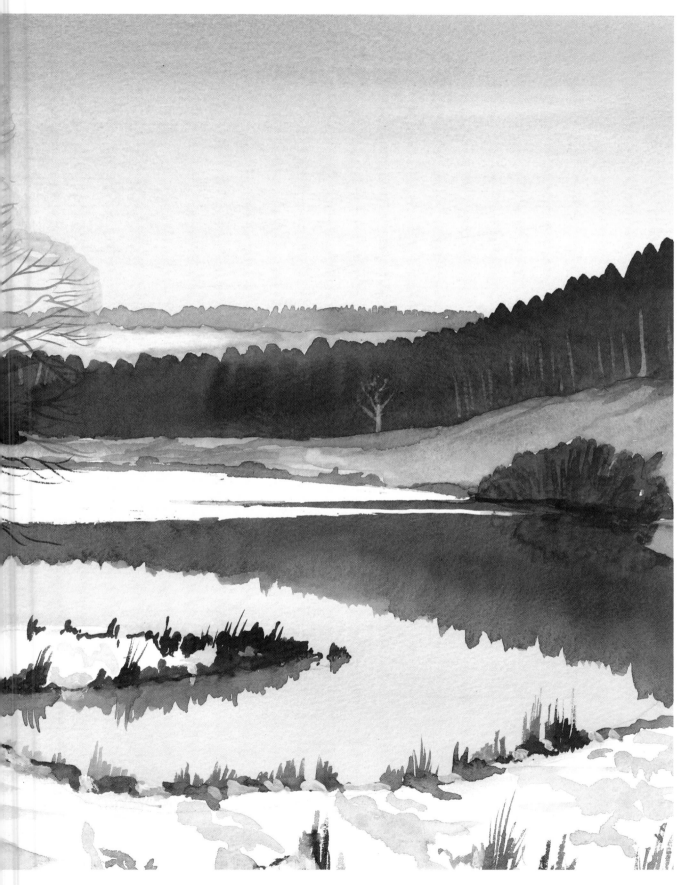

Water close to the spectator also looks darker, as the depths of the water or ground underneath is the predominant influence on tone and colour, rather than the reflection.

Even with small ripples across the surface, the predominant characteristic of calm water is that of a mirror, and the next few illustrations will demonstrate the mirror-like effects. With the principal reflection being that of the sky, it is essential when depicting calm water in watercolour, to master the wash. Without an ability to wash colours progressively more or less densely, you will be continually disappointed with the results of your efforts to paint water. The most simple wash to demonstrate water is shown on this page. Washes are best handled using a large soft brush such as a No20 or 16. Large pans for mixing colour are essential, either in a watercolour-box lid or in separate saucers, as plenty of water is the key to a successful wash.

The type of paper you use has a major impact on the appearance of a colour wash. If it buckles your wash will not be constant and will dry at a different rate in different areas, leading to all sorts of problems. To avoid buckling, you either need to use heavyweight paper of 140lb or more, or you need to stretch a lighter paper. Stretching paper is described in many books on techniques of watercolour painting. The surface of the paper, whether rough or smooth (the various terms of which have been outlined in the materials section, see page 18), has a considerable effect on a wash, as does the angle at which the paper rests, when applying the wash.

Again, different colours affect the end result. Certain paints granulate, which means that they sink into the pits in the paper surface leading to a spotted or crazed effect. There are many variables at work: paper surface, paint, angle of the paper, weight of the paper and finally, size of brush and amount of water used. All together it leads to one conclusion: practice is essential for success. In the illustration of a simple wash on this page, ultramarine blue was applied with a wet No20 brush across the top of the paper. With increasing dilution strokes across the paper were made to achieve a graduated wash, the paper being at 30°. Past the halfway point down the paper the colour concentration was progressively increased with a stronger ultramarine at the bottom. Although you may consider it wasteful you should practise a wash such as this perhaps using different papers and colours many, many times; painting water in watercolour depends so much on effective colour washes.

When a reasonable wash has been achieved and is

A typical wash which is an inherent feature of all still water paintings. Using a large brush with plenty of water a delicate gradation of tone is possible.

A simple silhouette provides the start of a lakeside painting. Note how the reflection is slightly different in tone.

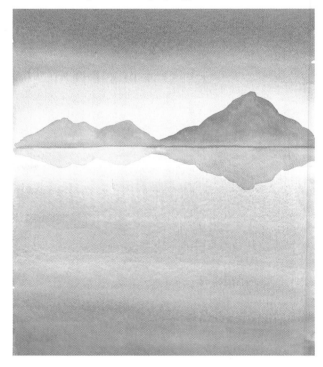

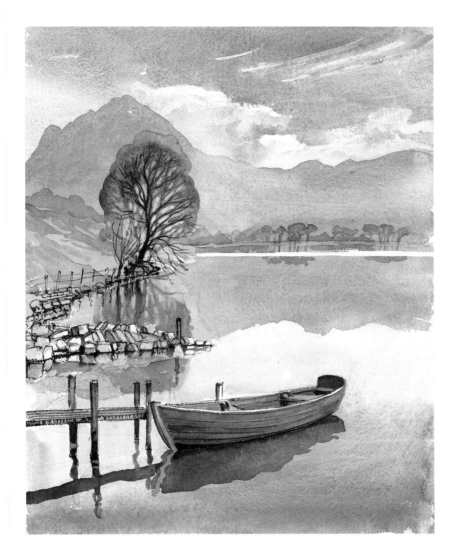

Buttermere Lake
Watercolour, 16×12in (41×30.5cm).
Using washes for sky, mountain and lake this watercolour typifies the still water landscape which can develop from the basic washes shown opposite.

thoroughly dry (a hair-drier is a valuable piece of studio equipment) you can add simple features to represent a landscape, such as the mountain outlines in my diagram. A line through the middle represents the horizon – you now have the basics for a waterside landscape.

It is possible to find a lakeside with perfect reflections as is illustrated in the painting above from the English Lake District. Such stillness enables the reflections to be painted with little distortion. You can see how significant the wash is – for sky, mountains and water.

At this stage, it is useful to introduce the concept of aerial perspective. Objects in the distance are usually painted in less strong colours and tones than similar objects in the foreground, ie the darks are less dark, the lights less light, and the whole colour spectrum is often moved towards the blue end. You will have noticed this in the mountains where those in the distance look distinctly blue. The control of tone and colour for accurate and sensitive aerial perspective is another essential step on the road to successful waterside landscape painting.

With increasing confidence in applying washes you should experiment with wet in wet applications, where a second wash is added, either on top of an existing wash or joined edge to edge before the first wash is completely dry. In this way, blurred edges will result and colours will change. Often for reflections in water, a blurred edge will provide a more realistic result than a hard edge. Also a reflected image is usually somewhat darker in tone than the object. Looking at the reflection of the boat in the painting above you can see it is very slightly darker than the boat itself.

To sum up, master your washes, practise on simple paintings again and again before pursuing more complex paintings. Get to know the effects of different papers, brushes, paints and techniques. Use lots of water and be bold with the brush using the largest brush feasible.

In other media such as oils, acrylics or gouache, the wash is not used to the same degree.

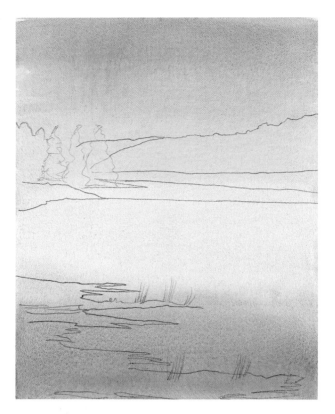

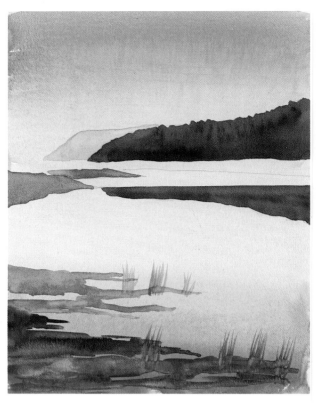

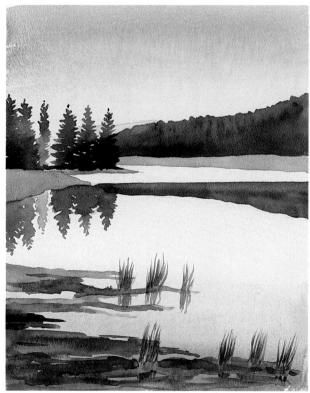

Stage 1 △
Initial Wash

An outline sketch is drawn using an HB pencil with key landscape lines added. Note how lines for the reflections have been left out to avoid pencil lines in the final state. A wash was then brushed on using ultramarine and yellow ochre.

Stage 3 ▷
Details

Pine trees were added using sap green/ultramarine and a No. 7 brush. The lakeside in front of the forest was washed in to suggest shadow and the reflections of pine trees and spiky reeds were added.

Stage 2 △
Secondary washes

The forest was washed in using Van Dyke brown and Payne's grey. A No. 20 brush was used to indicate the tree tops on the skyline. Other washes used yellow ochre, sap green and Van Dyke brown. The spiky reeds in the foreground were touched in using a No. 2 brush while the wash was wet.

Stage 4 ▷
Finished Painting

Watercolour, 16×12in (41×30.5cm).
Paint was lifted out of the forest to suggest tree trunks and branches, using a wet No. 2 brush and dry cloth. The water's edge was added to shore and foreground and shading added to the lakeside in front of the forest.

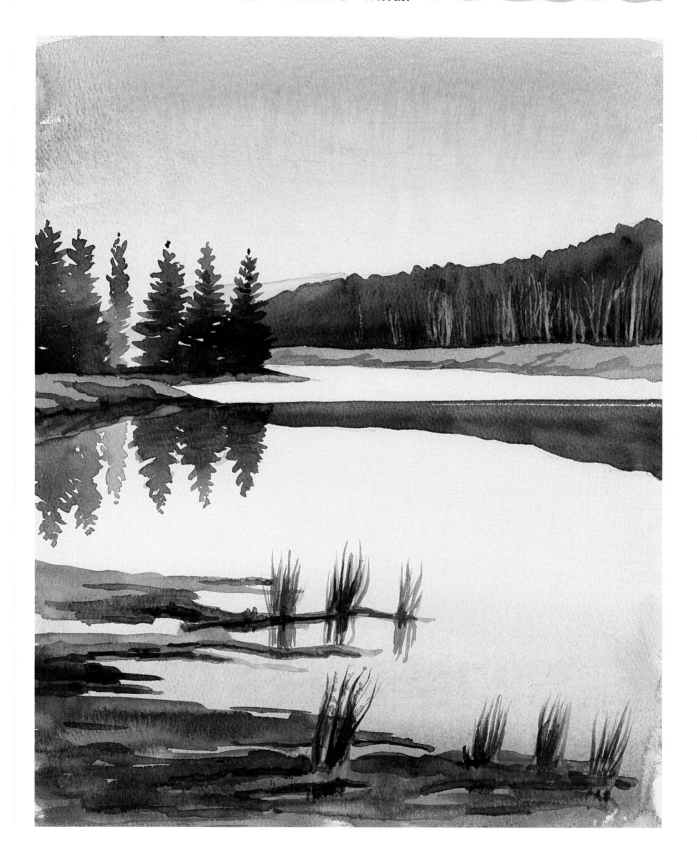

RIPPLES

The most straightforward approach to creating the illusion of simple ripples on the surface of the water is to paint or draw straight lines across the water, the lines getting progressively closer as they recede into the picture, as in the example right. The lines can be painted with a small pointed brush Nos2–5, and for greater effect can be broken to suggest multiple ripples. This approach can be surprisingly effective adding much greater realism to the plain washes we have considered so far.

This technique also means that reflections can be painted complete and without distortion with ripples added later as in the painting of *Falmouth*, in Cornwall, on this page. The effect of distance achieved by grouping the lines closer together in the distance is an example of linear perspective. The term used for this particular aspect of linear perspective is 'foreshortening'.

A further development of the technique of drawing lines to represent ripples is to use bands, rather than lines. Bands can be created by lifting colour out of a

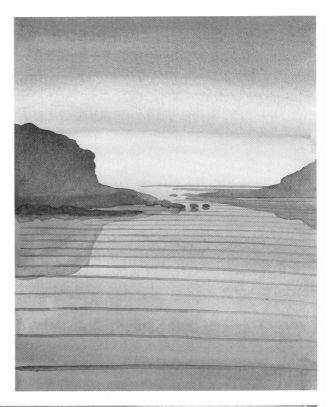

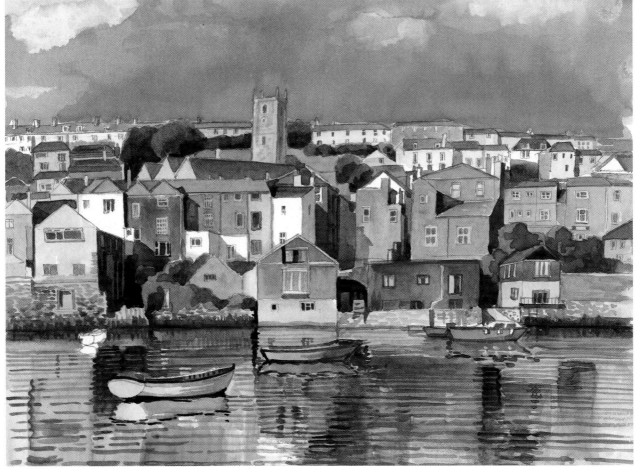

Opposite above
A simple interpretation of ripples can be achieved by drawing straight lines across the wash, with increasing spaces between the lines in the foreground to create a sense of depth to the picture.

Opposite below
Falmouth, Cornwall
12×16in (31.5×41cm).
The straight line ripples are seen here applied to a full waterside landscape.

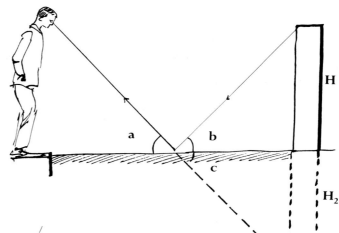

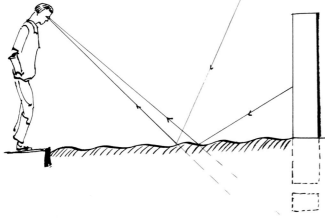

△ *Light is reflected by the surface of water at equal angles, ie $a=b=c$. The reflection H_2 looks to the viewer the same height as the object H_1.*

◁ *When the surface of the water is distorted by ripples the angle of the water's surface changes and the reflected light is interrupted as in this diagram.*

◁ *Ripples can be painted by 'lifting out' wet paint to form lighter tones as shown here.*

washed background with a wet or damp brush, thus creating a lighter strip. Sometimes a more effective result is achieved by lifting the colour out using a dry brush when the original wash is still wet. These methods can be used where wider ripples or waves are present. (See diagram and caption above.)

Unfortunately ripples are not always in straight lines. Throw a pebble into a pool and circles of ripples will spread out from the point of impact. Throw two pebbles in at the same time and all types of complex patterns emerge where the ripples intersect. Add some wind to the situation and an enormous complexity of surface patterns develops. To paint in this situation you have to simplify. Ignore minor ripples, concentrate on the principal movements. Make it simple, use clean clear brush strokes and try to think through ways of clarifying the water's movements to enable you to paint realistic impressions.

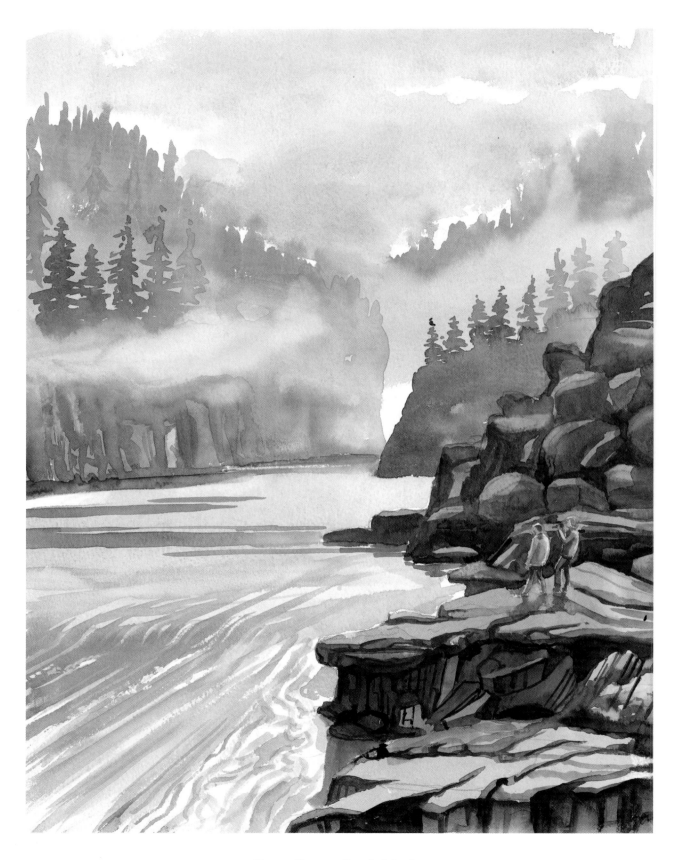

Frazer Canyon, *British Columbia*
Watercolour, 18×14in (46×36cm).

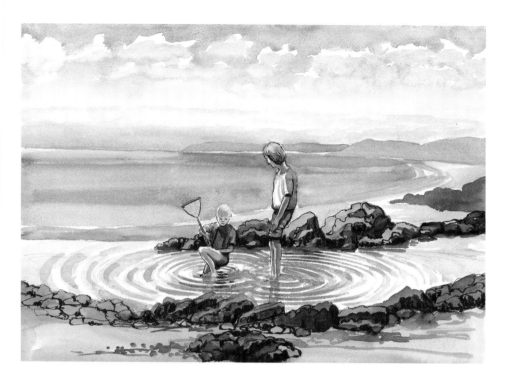

In this sketch of children in a rock pool the ripples have been emphasised to illustrate their circular nature and the light and shade effects. The diagram below illustrates the theoretical light and shade effects from such circular ripples. In the watercolour opposite, ripples suggest movement and changes of level in a flowing river. The handling of moving water is explained in detail on pages 34 to 37.

Circular Ripples

With circular ripples, for example, children in rock pools on the beach or an angler wading into the river to fish, the light striking the expanding ripples will create curved circles, requiring the same approach as before of lifting out colour from the wash – or alternatively you can apply opaque paint such as gouache white. Note, however, that the light striking the side of the ripple will appear to change sides as indicated in the simplified diagram on this page and shown in the sketch of the two children in the rock pool. In the sketch the ripples have been deliberately emphasised and also given is an indication of the effects of intersection, where complex patterns emerge. In reality one would not produce such exaggerated ripple effects, but suggest the ripples with fewer circles.

Another point which arises from the sketch of the two children, not related to the ripples, is the difference between shadow and reflection. The reflection comes towards the viewer, the shadow goes away from the sun, giving two different directions. This can often be confusing and to clarify matters you may need to reduce one or the other. Often the shadow is less predominant, and less important in creating the illusion of water.

A further confusion can arise when you can see objects through the water such as the children's feet. In the sketch this has been ignored, but if you need to show objects under water, they are distorted by refraction. It

is better that you do not attempt painting where reflection, refraction and shadows all apply to the figure – unless you have considerable experience in drawing and painting.

You will have realised that painting objects in water using watercolour is not a simple, straightforward procedure. Practice is essential, and careful and continual observation will help. Look to see how experienced painters handle the problems. Sketch often at the water's edge and look at photographs of people swimming or standing in water. Work on the simplification of all the effects into something which is understandable and paintable.

Watercolour is not the easiest medium to handle and for beginners who choose watercolour because it is clean, simple and of low cost, the difficulties of handling the medium successfully may be so great that they abandon the attempt and take up growing roses! The skill necessary to paint a competent watercolour picture is certainly greater for the beginner than that required to achieve an acceptable result in oil, gouache or acrylic.

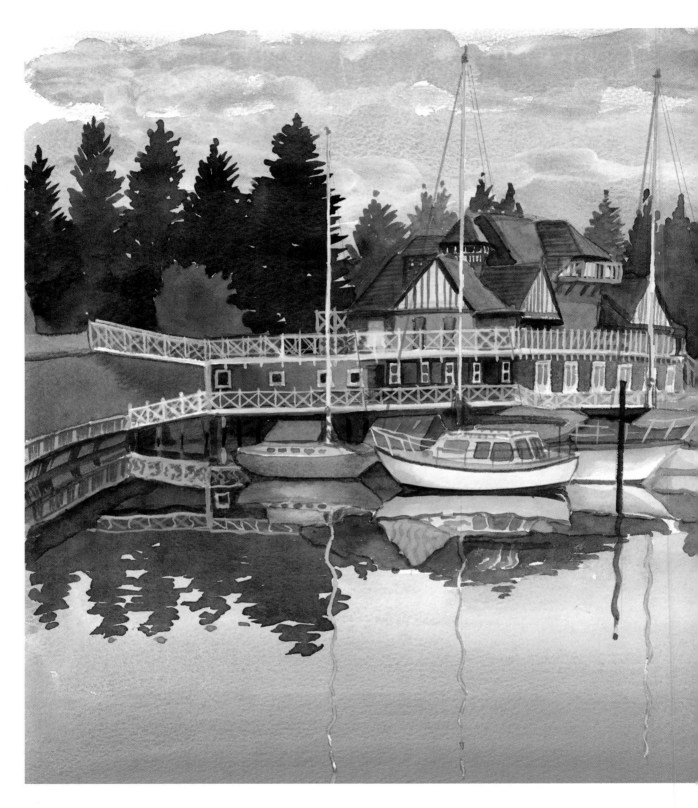

Vancouver Rowing Club
Watercolour, 12×16in (30.5×41cm).
*Reflections of the boats and the clubhouse
on a calm grey day in a Canadian winter
illustrate the characteristics of reflections.*

*Straight lines become wavy and the tone
of reflections is less pronounced, hence
the reflections of the white boats are
darker and the dark trees lighter than
the real objects.*

30

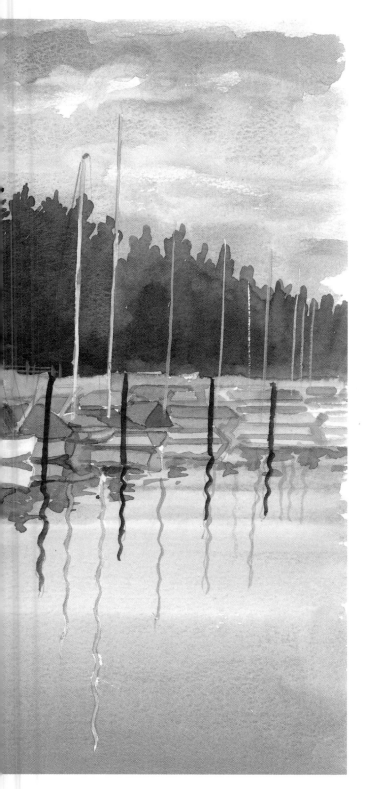

REFLECTIONS

An essential aspect of painting water in any medium is reflections. As indicated earlier an exact copy reflection, an upside-down replica of an object, often appears unreal. Reflections are frequently distorted in shape and are different in tone and colour from the original object. A light object has a darker reflection and vice versa. Even an apparently still stretch of water will create distortion to reflections and straight lines will appear wavy. To create the illusion of water it is useful always to use wavy lines. Distortion is particularly noticeable in reflections of masts and posts, where the reflected line has distinct waviness with gaps in the reflection. Also, reflections often have blurred details and can be represented by simplified brush strokes.

Most of these effects can be seen in the painting of *Vancouver Rowing Club*, opposite. You can see that the reflection of the trees is less strong in tone than the trees themselves, the reflection of the white boat in the foreground being darker than the boat. The reflections of masts and poles have a distinct waviness and the reflections of the white railings are blurred compared with the railings themselves. The water was washed in without ripples or reflections of the clouds, relying instead on the wavy lines of the reflections of posts and boats to suggest the slightest movement of the water. The simplified treatment of water, trees, grass and sky helps to balance the complexity of the buildings and surrounding boats.

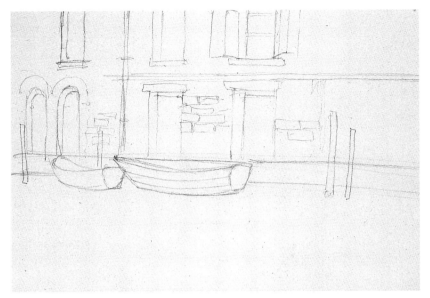

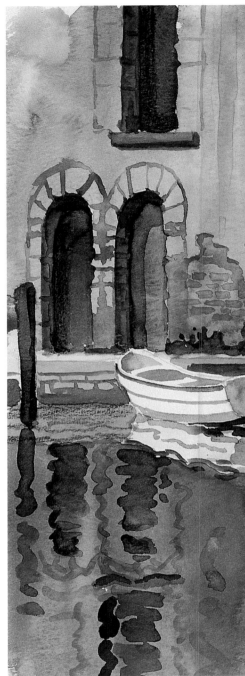

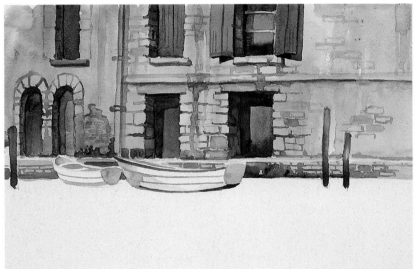

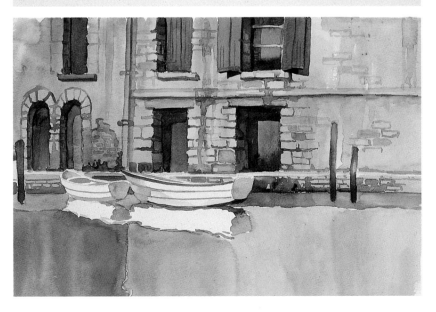

REFLECTIONS
Stage 1 (Top left)
A pencil drawing outlines the key features
of the buildings and boats. No pencil
lines are used for the reflections to avoid
lines appearing on the final picture.

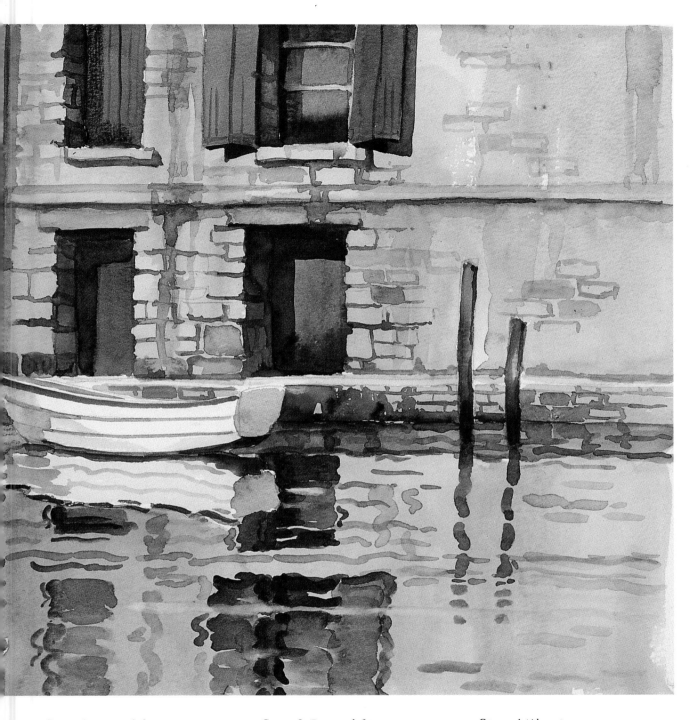

Stage 2 (Centre left)

The buildings and boats are painted using an initial wash for the background colours of raw sienna, cadmium yellow and Venetian red. The doors and shutters were added with Payne's grey and sap green, and the brickwork picked out. Shadows on the boats were added using cobalt blue and Payne's grey. Final shadows were painted in.

Stage 3 (Bottom left)

The initial wash for the water was painted using darker tones than the buildings and leaving blank paper for the boats. Note the wavy edges around boats and jetty. The shadows on the stern and underneath the boats were added.

Stage 4 (Above)

Reflections of doors and windows were added; note how gaps have been left across the reflections to suggest ripples. Try not to overwork the reflections, keeping washes simple. Also the reflections of boats and buildings should be in vertical alignment. Final details were then added.

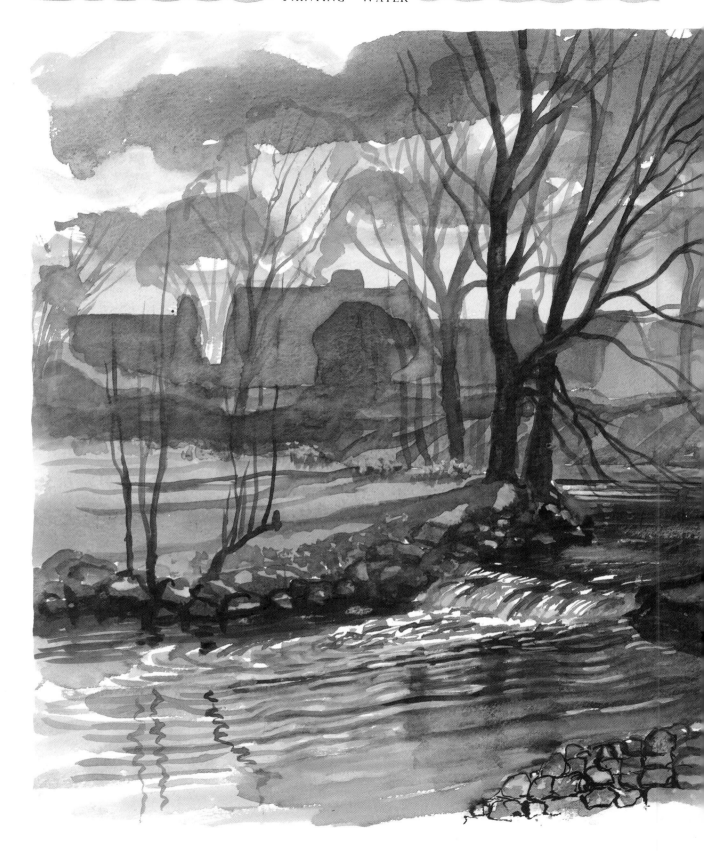

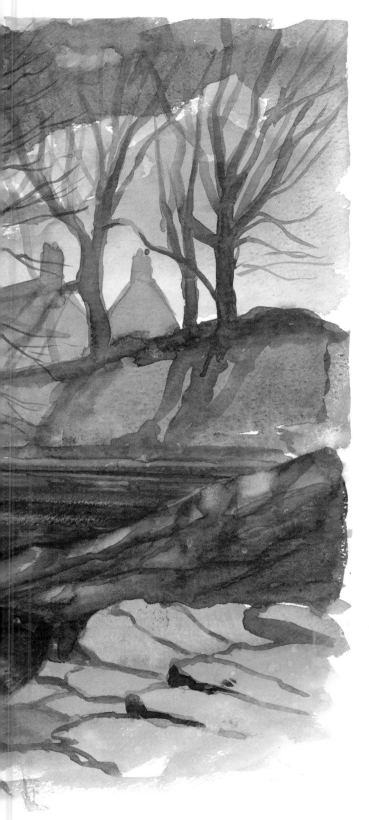

MOVING WATER

From still water to moving water can be a smooth process with the use of reflections and ripples carried over from the earlier still-water exercises. Moving water has direction and in rivers often goes over rocks and other changes in the riverbed. The way it moves along the river or over rocks can be depicted by lines which describe the movement. Thus if water moves along the river round a rock and over a ledge a set of lines which follow this movement can be entirely realistic. This approach is shown overleaf in a stage-by-stage example.

In the painting on this page the movement of the water is shown by the small waterfall and subsequent ripples. These are described by light or dark lines following the flow – with some curved ripples downstream. The lighting of this picture is dramatic, with a wide tonal range, dark clouds gathering and light creating shadows across bank and meadow.

Riverside at Ravenstonedale
Watercolour, 12×16in (30.5×41cm).
Moving water has direction and turbulence
with some calm areas in the smoother
stretches. Light reflecting on the surface
can suggest the direction of the water's
flow and gives form to waterfalls.

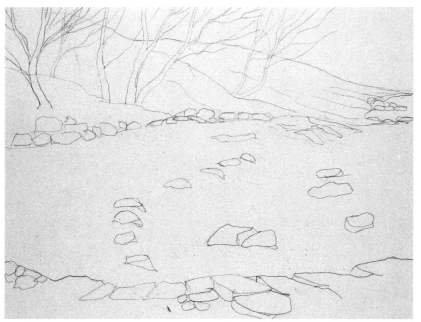

MOVING WATER
Stage 1
An outline was drawn in using a 2B soft pencil. Note how the composition leads the eye into the painting. No pencil drawing of the ripples was made to avoid lines appearing in the final stage.

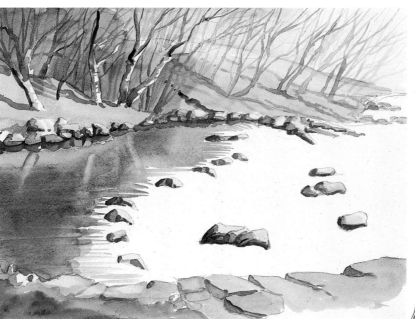

Stage 2
The background landscape was washed in using yellow ochre, sap green and Van Dyke brown. When dry the dark area of trees was added with spaces left for the light on the tree trunks. The initial reflection was painted on the water using the same colours as the landscape and lifting out the tree trunks. Rocks were painted with Davy's grey, Payne's grey and Van Dyke brown, with foreground rocks in sap green.

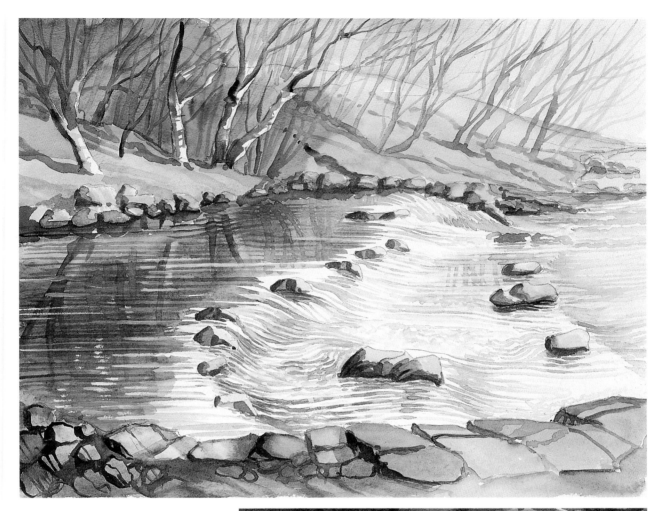

Stage 3

Reflections of trees were added to the calm water areas and straight line ripples painted across in the direction of the flow. Gouache white was used to add light to the ripples. Turbulent water was drawn in with a succession of cobalt blue lines. Some lines of darker tone increased the realism with areas of turbulence added. Gouache white was used in spots to suggest highlights. Faint reflections were added to flat areas of water. The close up shows the simple basis of cobalt blue lines to suggest the flow of the water.

3
The Sea

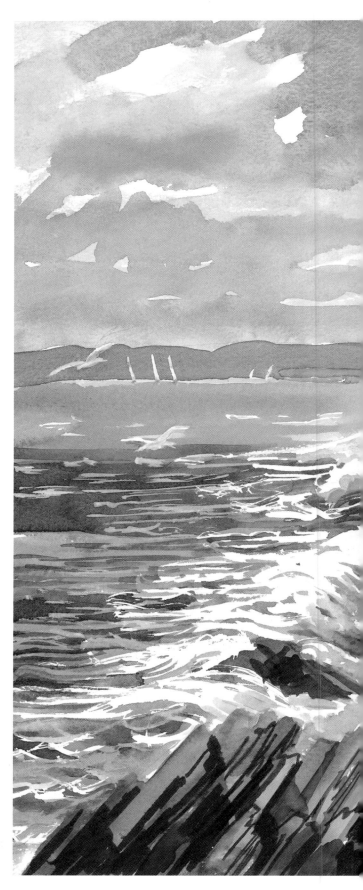

For drama, excitement and energy the roaring surf has no equal among waterside scenes, with the awesome power of the waves as they crash on to cliffs and shore. For the painter, and equally for the musician and poet, the sea has always had a binding fascination. Turner's masterpieces come to mind, of storm-tossed waves with sea and sky combined in a whirling turbulence of spray, spume and cloud. Not all of us can aspire to such heights of dramatic portrayal as Turner, but nevertheless the sea has a great attraction as a subject, whether it be from the beach, from distant cliffs or on board ship.

In practical terms you can see immediately that the mirror-like quality of still water has disappeared – unless you are painting a small harbourside view or a rock pool on the beach. Waves at sea have a sculptural, three-dimensional quality. They have form and shape which have to be portrayed. They also have texture, the surface of the water is multifaceted, with small ripples and wavelets. Many colours appear in the waves, the blue-green colour of the water, the transmitted colours of sand, and rocks underneath or the reflected colour of the sky above.

Above all, the sea has movement without which any seascape painting will miss its prime characteristic. The challenge for the artist, therefore, is to portray a moving, three-dimensional multicoloured surface – with feeling and atmosphere.

Sun and Surf
Watercolour, 16 × 20in (41 × 51cm).

To capture the movement and shape of waves breaking on to the coast is a challenge. In this watercolour painting masking fluid has been used to create streaks of white spume and spray with cobalt blue shading on the wave crests adding a three-dimensional character.

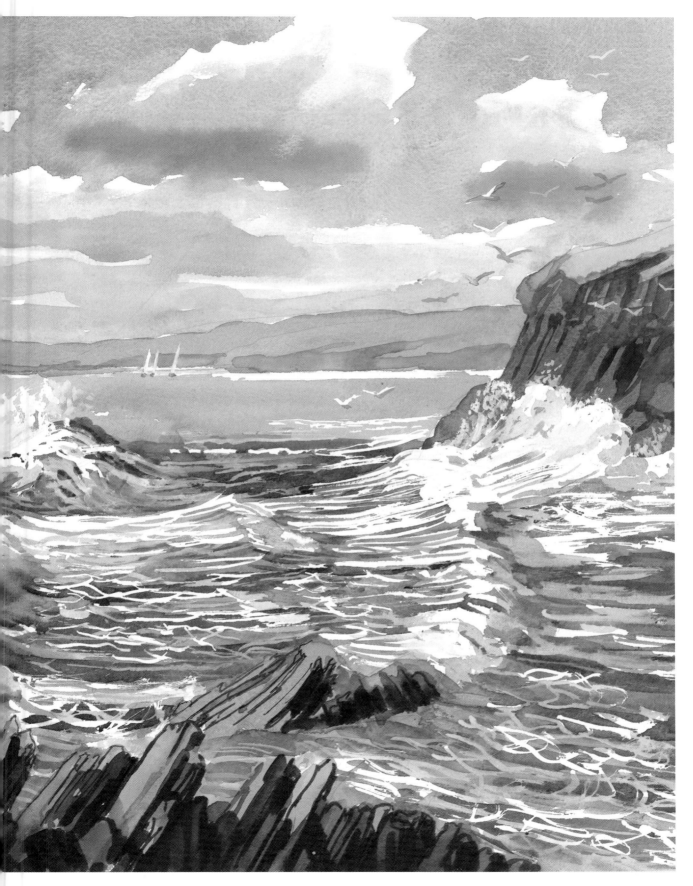

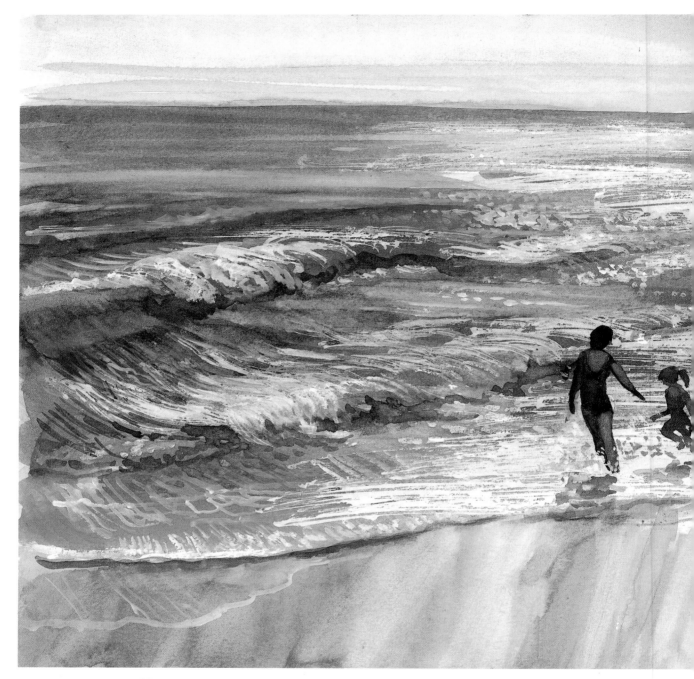

WAVES

Bright sparkling light reflecting from sea and surf, hot sands and running children make for exciting visual images, but may be a daunting prospect for the leisure painter.

How do you tackle such a challenge successfully? In the two paintings on this page, I have tackled the complexity of breaking waves by choosing to look into the sunlight. This emphasises contrasts of tones between light and dark and strengthens the form of the waves by the strong shadows. The waves were simplified into major components, ie three or four waves at the most. In the watercolour I have made extensive use of masking fluid applied in streaks following the water movement. Hooker's green was washed on to the initial drawing, which used masking fluid. I then added more fluid to provide a variety of colour and tone to the streaks in the water. At the front edge of the waves, shadows were applied to give weight and substance to each wave. The figures were added in action poses to complement the movement of the waves, the principal objective being to capture light, movement and action in this surf scene.

40

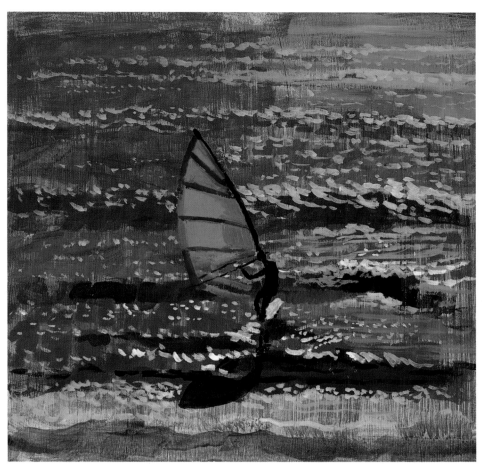

△ **Windsurfing**
Acrylic, 12×12in
(30.5×30.5cm).

*On a background wash of
neutral grey, wave forms
were added broadly in cobalt
blue and grey, with surf and
reflected light in cobalt blue
and white. Varying tones of
highlight using individual
brush strokes create a realistic
effect.*

△ **Splashing in the Surf**
Watercolour, 12×16in
(30.5×41cm).

*In this painting looking into
the light I made extensive
use of masking fluid, with
lines following the movement
of the water and the shape
of the waves. Shadows help
to give the wave front solidity
and form.*

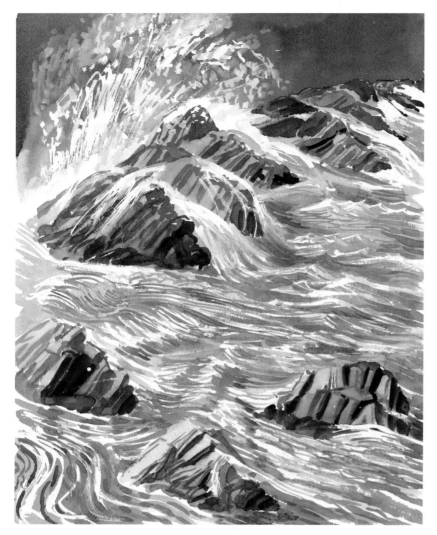

Breaking Waves
Watercolour, 16×12in (41×30.5cm).
Lines follow the movement of
the water through and over
rocks using masking fluid and
gouache as well as
watercolour.

SURF ON ROCKS

You will see that the painting above of waves hitting the rocks has used the linear approach from previous paintings of moving water but now combined with surf and spray. The essential difference is that now we have to describe the water in three dimensions. To do this I have added shadows to the front of the waves, often using cobalt blue, and the shape of the waves themselves have been described with lines made with masking fluid or with paint. Green was used as a basic colour for the water, a sap green and/or Hooker's green – water close to shore often has a greener appearance owing to the colour of the sand underneath. The procedure I adopted in order to give depth and variation, was to use alternate washes of colour and painted lines of masking fluid.

Following an outline sketch of the rocks I used a No2 brush to paint lines with masking fluid representing the movement of water and waves. The surf was also painted using masking fluid. This was followed with a wash of sap green. When thoroughly dry more lines of masking fluid were added then another wash of sap green. When totally dry the masking fluid was removed and some darker lines of Hooker's green were added. The shadows on the wave crests were touched in with cobalt blue. The rocks were painted using the technique described on pages 62–3 and sea spray was touched in with gouache white.

After a few practice attempts you should find this approach straightforward and quick. For the purists who do not wish to use masking fluid, a somewhat similar result can be obtained using white paper for highlights of surf and spray but it probably takes much longer and more hours of practice to achieve the finished result. Whichever route you take keep your painting fresh and loose. Swing your brush through the patterns of waves and eddies. Be bold, and if you fail first time, try again. If you are too timid in your approach the result will lack movement and dynamism – an essential characteristic of

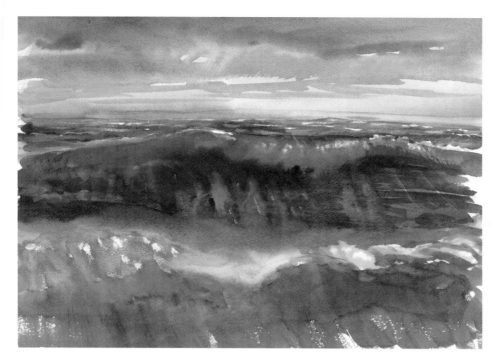

Ocean Storm
Watercolour, 12×16in
(30.5×41cm).
*An impression of a force 8
gale from a yacht at sea
created by manipulating wet
washes of Payne's grey and
ultramarine with added
touches of Hooker's green
and gouache white.*

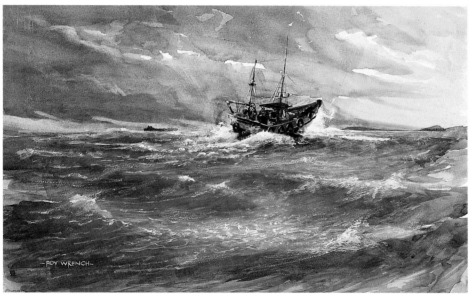

**Off to the Fishing
Grounds** by Roy Wrench
Watercolour, 12×16in
(30.5×41cm).
*This lively painting has
captured the peaks and
troughs of a stormy sea with
the drama of the boat
crashing through the waves
as the focal point. The choice
of colours has provided a
sense of stormy weather and
a distant glimpse of a ship
on the horizon has added
space and dimension to the
picture.*

water and surf. A lively handling of the sea should be matched by a similar approach to the sky.

The two paintings above illustrate different techniques, the top being my own interpretation of the view from the cockpit of *Klondike Kate* when running before a force 8 gale. The seas looked enormous and as the boat rose above each crest an even bigger one appeared beyond.

A vigorous wash of very wet colour was employed using Payne's grey and ultramarine, lifting out the peaks, adding some Hooker's green and a few specks of gouache white to pick out the crests. The clouds were washed in loosely and the final result – always in doubt – captured exactly the feeling from the cockpit – horror!

The other painting shows yet another approach from a fellow artist and sailor, Roy Wrench, who has produced an atmospheric watercolour using browns, greens and blues to achieve an overall harmony in the picture. Note how he has strongly emphasised the shape and form of the waves simplifying the basic three-dimensional forms before adding surface texture of small ripples, white streaks and breaking tops. The fishing boat rearing over the crest in a cloud of spray adds drama and excitement.

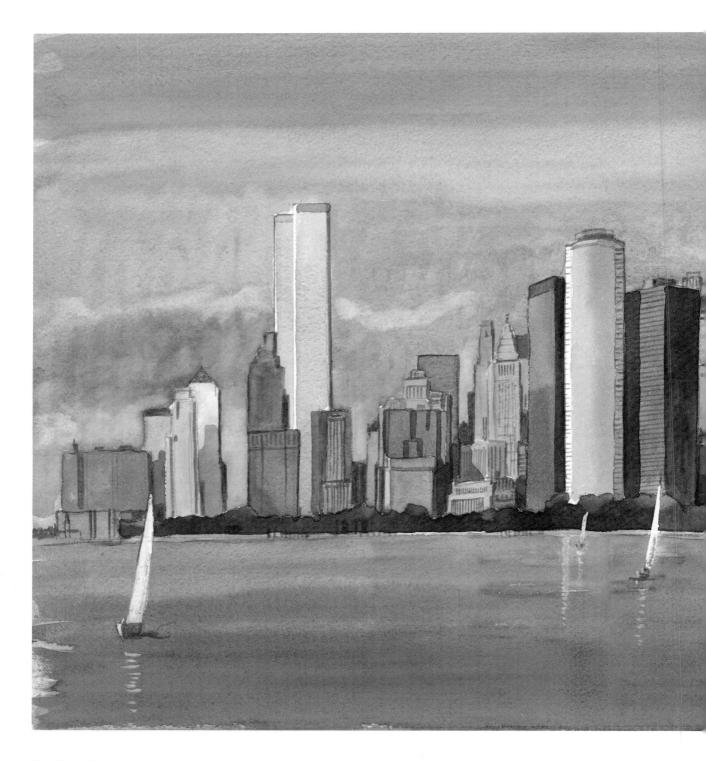

New York Harbour
Watercolour, 14×18in (36×46cm).
*From New York's mighty skyline to a
tiny fishing port, harbours provide a
range of subjects. In this view from the
Staten Island ferry, I have tried to
capture the strange lighting of the
smog-laden atmosphere of a July day.*

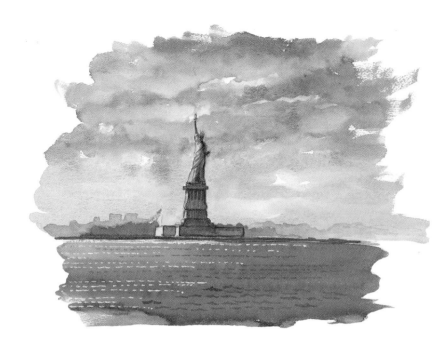

HARBOURS

From the lofty waterfront of New York harbour to the tiny fishing village tucked away on a deserted coastline, the harbour provides a fascinating range of waterside landscapes. Challenges abound such as sketching the *Statue of Liberty* from the Staten Island ferry, above. The waterside artist has a multiplicity of subjects and much to explore. The problems of subject selection, composition, drawing ships, yachts and boats, handling the bright colours of sails and windsurfers often leaves the painting of the water itself as a secondary issue. The technique of painting still water and ripples described earlier (see pages 20–9) can usually be enough to cope with most harbour scenes. Reflections, however, can be complex and creating simplicity out of complexity can be critical to success.

Selecting a subject in the harbour will depend on your competence and confidence. Your ability to draw boats will clearly influence your choice and for some painting harbour scenes can be problematic. Drawing yachts and boats is covered fully in the next section.

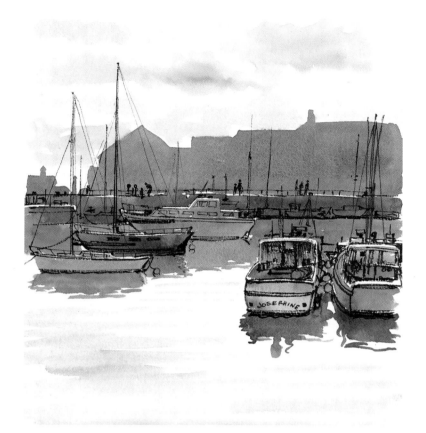

◁ *Harbour Evening*
Watercolour sketch, 12×16in
(30.5×41cm).
*Simplification can ease the task of
painting in the harbour. This sketch
comprises washes and outlines of boats
with an almost monochrome colour base.*

▷ *Tewkesbury* by Brian Lancaster
Watercolour, 16×20in (41×51cm).
*The complexity of the subject has been
simplified with clean washes and loosely
applied detail in this beautiful
watercolour. The composition
encompasses the dominant mill building
to the right yet still achieves balance and
harmony with the focus clearly being on
the boats in the foreground.*

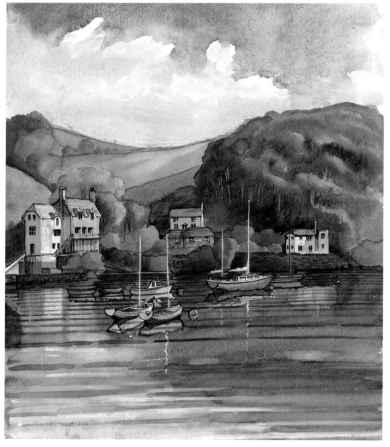

◁ *Yealm Estuary*
Watercolour, 16×12in (41×30.5cm).
*A marked contrast to New York harbour,
this quiet corner of Devon, England,
provides a colourful landscape background
to a few boats in a sheltered bay. Note
how the simple treatment of ripples is
applied over the reflections.*

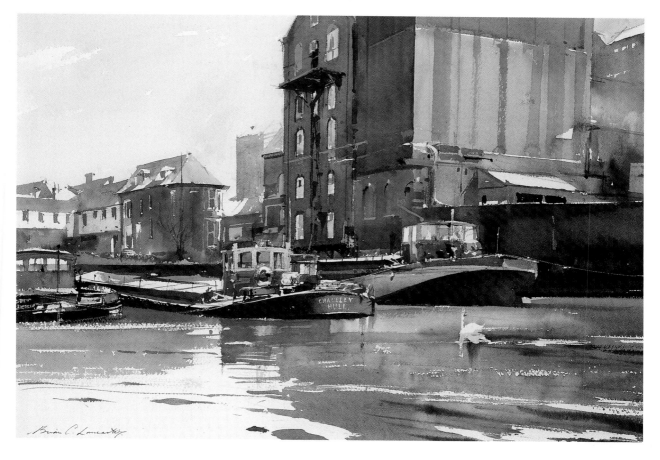

Simplification

Simplification can ease the task of interpreting harbour scenes. For example, a silhouetted profile of the harbourside, still water and an outline of one or two boats has been used in the sketch of Padstow harbour, left. This almost monochrome study looking into the light early in the year used a pen drawing to detail the boats, having first washed in the boat and harbour outlines. From such a simple interpretation more colourful and detailed studies can follow such as the painting of the *Yealm Estuary* in Devon, below. Note how this painting again uses the linear approach to painting ripples. The objective of this watercolour was to capture the peace and serenity of this corner of Devon, with the colours of the countryside reflecting in the still waters of the Yealm estuary.

Composition

The distribution of the elements of your subject in order to make an attractive and cohesive result is the art of composition. For this there are a number of guidelines, from the simple to the exceedingly complex. In essence, the underlying elements of composition create balance and order which will subconsciously give pleasure to the viewer.

The old masters and traditional schools of painting had quite extensive formulae for geometric constructions on which to base their work but for the average painter a simple set of guidelines will usually suffice. The more skilful the painter, the more he will vary the rules and manipulate his composition to create the mood and feeling he wants to convey – using dramatic layouts, imbalances or extremes and yet still producing an acceptable composition.

Look at Brian Lancaster's fine watercolour on this page. It shows an inland harbour at Tewkesbury in the heart of England and you can see that he has placed a massive warehouse in quite a dominating position. Nevertheless, by the layout of other components he has achieved a pleasing balance. He has ensured that your eye focuses on boats in the foreground, and even the swan plays its part in the composition; if it were not there a gap would exist which would lessen the balance in the picture. From the simple sketch to the complex finished painting composition is important to achieve a satisfying end result.

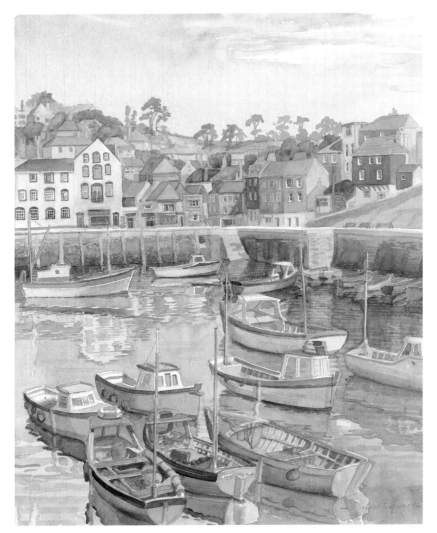

◁ *Mevagissey*
Watercolour, 20×16in (51×41cm).
With the horizon placed high in the picture the foreground has to provide interest and a composition which will lead the eye through the maze of boats.

▷ *Composition Sketches*
Typical compositions are illustrated in these sketches. The top is an L-shaped stable layout which creates a focal point at the corner of the L.

The next sketch shows a one third, one third, one third composition — the top third being sky, the middle houses and the bottom sea. This arrangement avoids dividing the composition in half.

The third sketch shows a typical lakeside scene which is over-centralised. The gap between the trees would be better off-centre.

The bottom sketch shows a triangular format; the triangle is frequently used to strengthen a composition.

▷ *Porlock Weir, Somerset*
Oil, 20×24in (51×61cm).
A classic composition with an off-centre focus on the black houses and a curving path leading into the picture. The hillside helps to balance the painting, and boats, houses and figures add interest to this landscape.

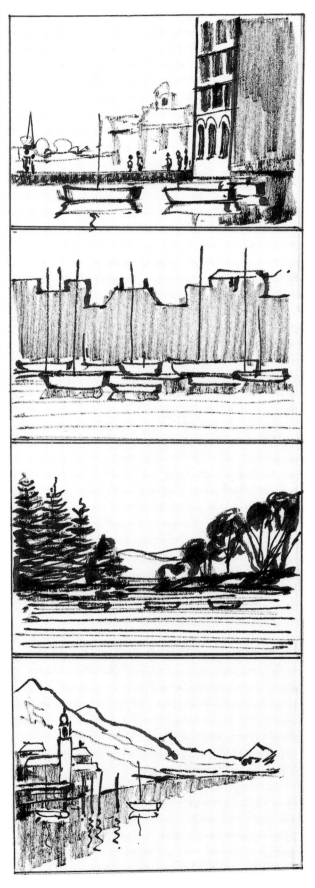

Although there is not space in this book to cover all aspects of composition I have included examples and sketches opposite to demonstrate key points. Avoid strong lines or bands which divide your picture totally from side to side or top to bottom. In the painting of Mevagissey, left, the harbour wall provides a strong horizontal which could be reduced by lightening the tone of the wall or emphasising the verticals of the yacht masts crossing the line of the harbour wall. This painting also has a high horizon, which adds complications to the composition of the rest of the painting. A more normal approach would be to have the horizon one third from the top and perhaps the harbour wall one third from the bottom. Certainly you should avoid dividing a picture completely in two either horizontally or vertically.

With a high horizon (or low horizon) one has to fill the space in the major portion of the painting in such a way as to create interest and a path for the eye to get into the picture. In the Mevagissey painting the many boats help to complete the composition, with the eye meandering through the complexity of the boats into the heart of the picture.

The painting of *Porlock Weir*, below, shows a different approach with an off-centre location for the focal point, the end of the cottages, which is balanced by the wooded slopes to the right. The path in the foreground curves into the picture. If the black end of the cottages were central and the path led straight to it, a boring composition would result.

Note how I have tried to maintain interest in each area of the painting with details such as the pink house, boats, trees, clouds and so forth. When you look at pictures in this book and elsewhere, it's useful to try to analyse the underlying structure and composition. If there isn't one that is apparent and the picture is still a success, try to work out why and remember it for the future!

There are many other geometric foundations for traditional composition. It is useful to analyse the basics of composition and then assess paintings in exhibitions to determine what approach the artists have used when composing the paintings.

BOATS AND YACHTS

Waterside landscapes inevitably include ships, yachts or boats, if not as the principal subjects, such as in this painting of tugboats in New Hampshire, then as supporting elements in paintings of rivers, harbours, canals or lakes. Often boats can be easily repositioned to help the composition, or to add colour and interest. Usually they have an elegance and beauty which can contribute much to your waterside landscape. Many marine artists devote their career to the painting of ships and boats, from the elegant tall sailing ships of old to the sleek modern warships or liners.

Because of their ubiquity in waterside landscapes and the difficulty expressed by many in capturing their form and elegance, several pages have been devoted to the treatment of boats and yachts. It is not difficult to find that having drawn an excellent boat, it appears to float above the surface, or is rigid and stiff rather than gracefully bending to wind and wave. Fortunately, most boats have common fundamentals of shape and form, the rowing boat, racing yacht and liner sharing the basic rules of naval architecture and design. It is useful to look at a wooden rowing boat built in the traditional way with keel, ribs and planks and think of all boats having a similar underlying structure. This is the same as in the life class where it is essential to have an awareness of the underlying structure of bones and muscles in the human body. When you achieve an understanding and confidence in handling boats and yachts, it will enable you to add a great variety of subjects and compositions to your waterside landscapes.

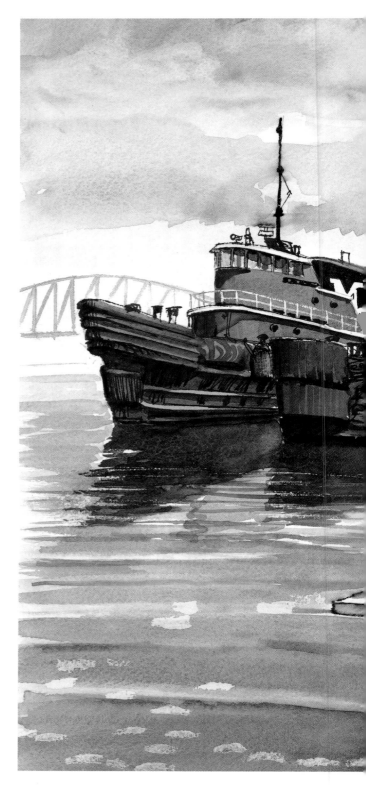

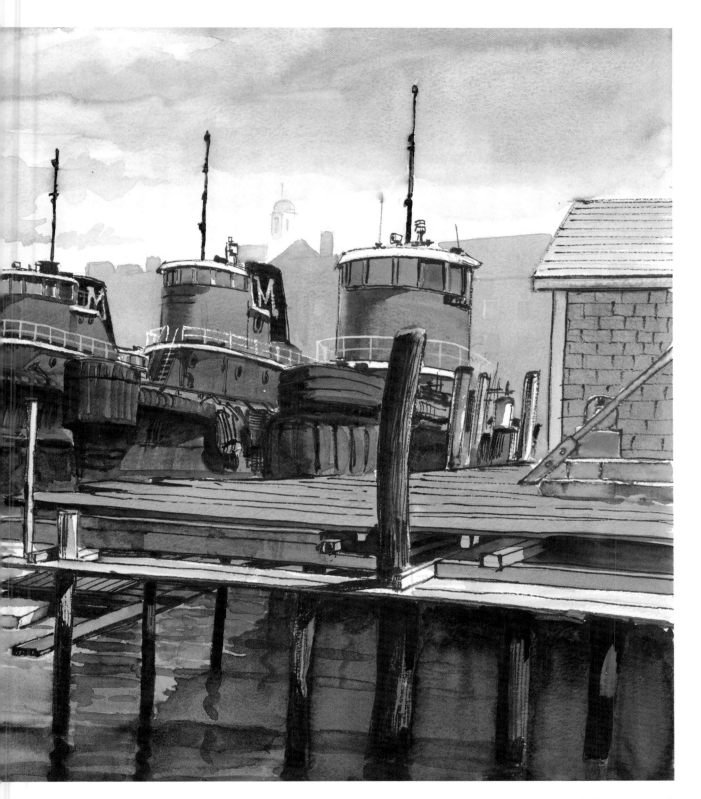

Tugboats in New Hampshire
Watercolour, 16×20in (41×51cm).
The attraction of these tugboats was the
marvellous colour and shape of the
individual boats. Moored at Portsmouth,
New Hampshire, the boats are on call
for duty and while sketching three
disappeared from the harbourside to
return later.

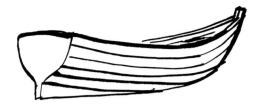

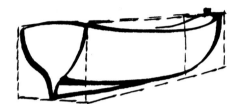

Drawing rowing boats can be assisted by the use of the 'figure 8' diagram as shown above. For achieving correct perspective a box can be drawn, as shown, into which the boat is fitted. Perspective can be a problem when drawing large ships and the box is particularly relevant in these cases.

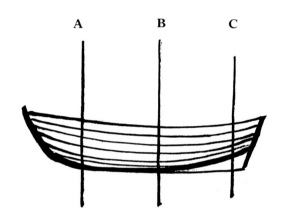

A B C

The shape of a rowing boat varies considerably from stem to stern as shown in the three sections A, B, C, and in the rear, front and plan views, right.

A

B

▷ **Boats on the Beach**
Oil, 20×24in (51×61cm). The structure of ribs, planks and keel in rowing boats make delightful patterns and shapes to explore in a painting. Practice makes perfect in drawing boats and a sketchbook on the beach is an essential aid to improving your understanding of the geometrical shape of the humble rowing boat.

C

It is often useful to think of a boat as a framework of ribs, keel and planks which will suggest the underlying form and structure.

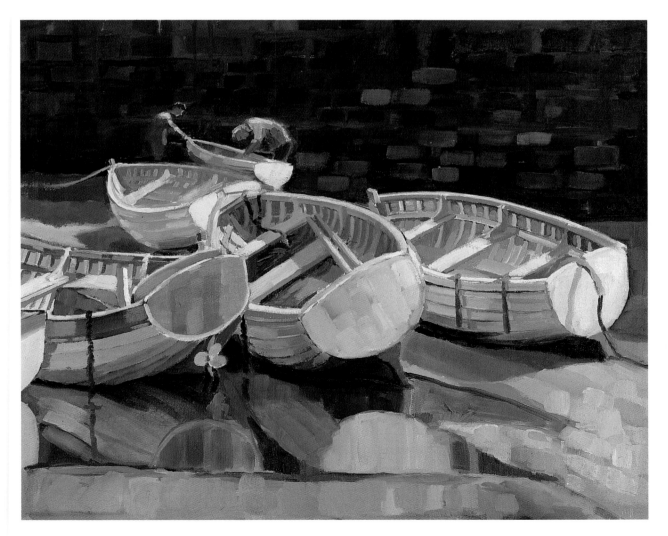

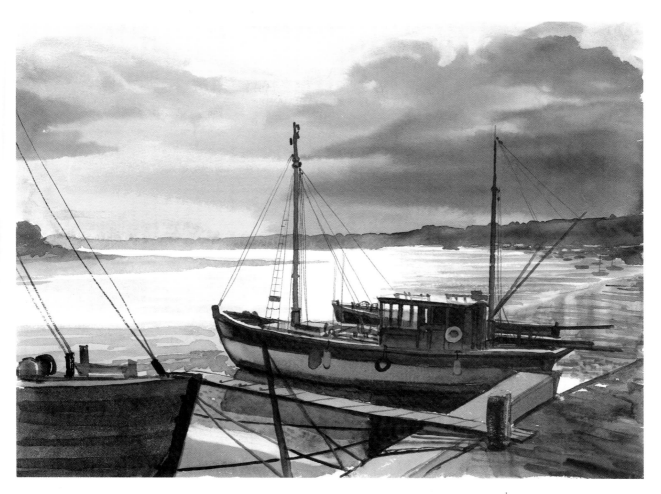

Fishing Boats at Woodbridge
Watercolour, 12×16in (30.5×41cm).
The backlighting silhouettes a converted fishing boat at Woodbridge. The flat open estuary of the Deben in winter creates an east coast feeling in this watercolour.

A sketchbook is invaluable to record the fascinating variety of ships and boats in any harbour. Practice will improve your understanding of the basic hull form and the many different types of vessel.

Yachts in Action

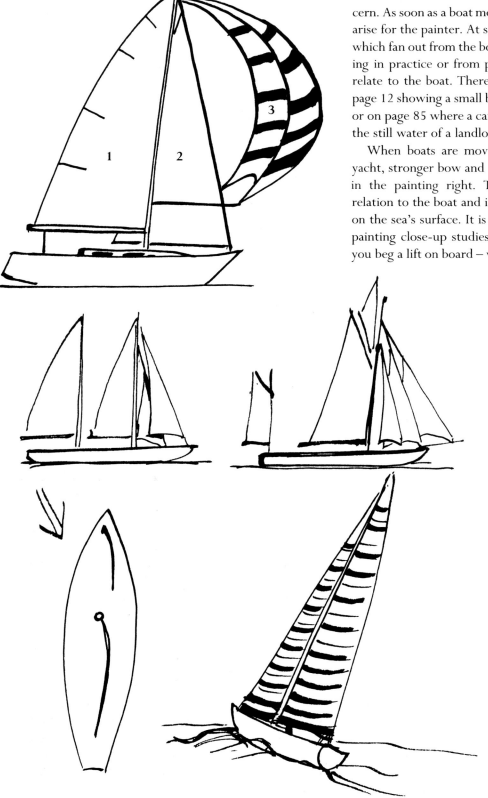

Most of the boats and yachts in previous pages have been shown on still water with reflections being a key concern. As soon as a boat moves in the water new problems arise for the painter. At slow speeds boats create ripples which fan out from the bow and stern. It is worth studying in practice or from photographs how these ripples relate to the boat. There are examples in this book on page 12 showing a small boat in front of the SS *Gt Britain* or on page 85 where a canal boat is slowly moving along the still water of a landlocked canal.

When boats are moving at speed as with a racing yacht, stronger bow and stern waves develop, as shown in the painting right. These waves can be large in relation to the boat and interact with the normal waves on the sea's surface. It is difficult to gather material for painting close-up studies of racing yachts at sea unless you beg a lift on board – which will be of little value, for

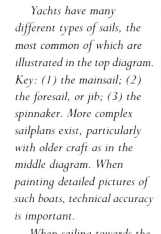

Yachts have many different types of sails, the most common of which are illustrated in the top diagram. Key: (1) the mainsail; (2) the foresail, or jib; (3) the spinnaker. More complex sailplans exist, particularly with older craft as in the middle diagram. When painting detailed pictures of such boats, technical accuracy is important.

When sailing towards the wind, the yacht heels away. With the wind behind, the yacht is usually upright. An understanding of basic principles of sailing is valuable to an artist, especially when painting yachts racing.

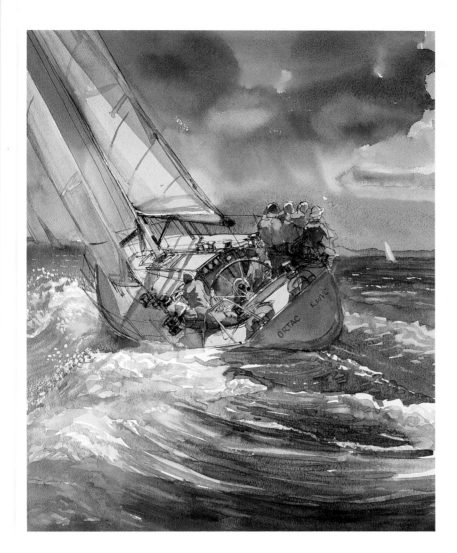

Racing Close Hauled

Watercolour, 20×16in (51×41cm). Conveying the atmosphere of excitement and windblown action is essential in racing yacht pictures. Difficult to paint in action without getting very wet, it is necessary to use reference material for a successful outcome.

sketching is virtually impossible on the heaving deck of a yacht on the wind. As a member of the crew, however, you would get a lasting impression of the action, excitement and drama aboard a highly tuned modern racing yacht.

Photographs abound of yachts in action and these can be informative. So too is sketching yachts in the harbour; these sketches can provide much information for later and can be transferred to an action scene at sea. Technical aspects of rigging, equipment, and so on can be complicated and errors are rapidly spotted by a yachting person, so if you hope to sell a racing yacht picture make sure the mizzen mast is where it should be.

Excitement can be generated by many aspects of your picture – a dramatic layout, a heavy sea with spray, scudding dark clouds suggesting stormy weather, a well-heeled yacht and crew at action stations, and spots of bright colours. In the picture above, the strong diagonal of the yacht itself, the extensive foreground emphasising

a stormy sea and threatening sky are principal features which I have used to emphasise the action inherent in the subject. The sea was painted with a preliminary wash of ultramarine and Payne's grey from horizon to foreground, leaving blank the yacht and surf, also leaving some white streaks of plain paper suggesting water movement in the foreground. The green/blue water between the crests was painted with lines of Hooker's green and ultramarine using a No6 brush, the shading of cobalt blue in the wave crests providing depth and form. The bubbling surf was suggested by wavy lines of ultramarine. Spray was added using spots of gouache. The sky was loosely painted using wet in wet techniques, the colours used were Payne's grey and raw sienna. The boat itself was completed using pen and wash. I introduced the pen drawing to the picture to cope with the rigging which in a close-up is an essential aspect. The spots of bright colour of the oilskins introduced some points of focus and interest to the scene.

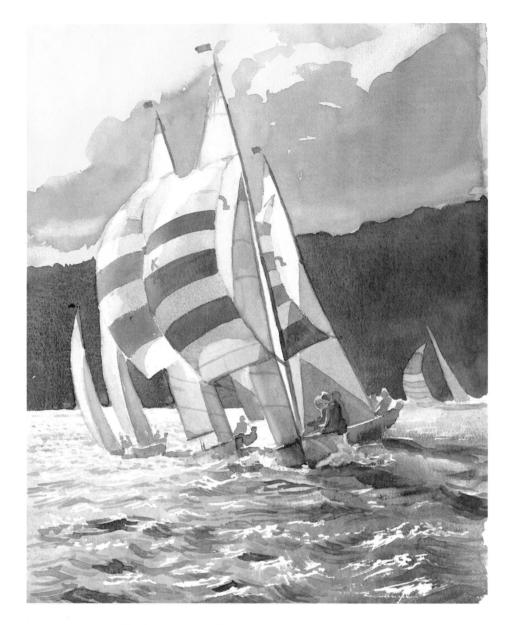

Spinnakers
Watercolour, 16×12in
(41×30.5cm).
*By starting with a wash of
yellow ochre over most of
this painting a feeling of
light in the finished painting
was created which permeates
its warmth throughout the
picture. The waves on this
lakeside scene were picked
out using masking fluid.*

Yachts on a Lake

A totally different viewpoint exists in the above water-colour of soling-class racing keel boats with their spin-nakers flying. On a lake the waves are not so dramatic and cannot be used to add much drama to the picture. The composition uses the group of boats to create an overall triangle, the billowing spinnakers with their bright colours adding a touch of colour and form to the scene. Here pure watercolour was used without the need of a pen to draw rigging wires.

I wanted to capture the light which diffused the whole scene so I washed a background of yellow ochre/cadmium yellow across the total picture after having first drawn the waves on the lake using masking fluid as previously described. When washing the background I avoided the sails of the yachts. Note how the fore-shortening between wave crests provides depth and recession in the picture. While the background wash was still damp some sap green and ultramarine was added to the sea on the right side of the picture in order to suggest the direction of the sunlight and to add variety of tone from one side to the other. The woods in the background were painted using a flat wash, and a simple cloud effect was added with Van Dyke brown and yellow ochre. The darker tones of woods and clouds em-phasised the white of the sails. The sails were carefully defined by shading – note how some figures are silhouet-ted by their backgrounds.

Having removed the masking fluid the waves and

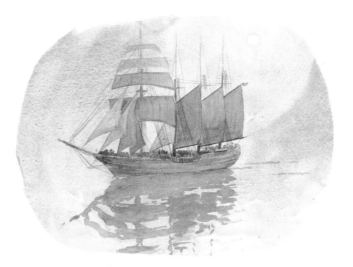

The Esmeralda at Plymouth
Watercolour/sketch.
It's a rare chance to see a tall ship in action, but the Tall Ships' Race in Europe each year provides just such an opportunity. Here the ship is caught in a hazy light with the sun dimly visible through the mist. Painting historic ships is a specialised form of marine painting requiring extensive research.

water were finished as described previously. Finally, shadows from the yachts on the lake's surface were added which helped to emphasise the direction of the sunlight and further create depth in the picture. The final result seems to capture the light and movement in the scene. I particularly liked the way in which the figures fitted into the composition, and added a sense of action.

Perspective

The perspective problems in painting a group of boats are considerable. Normally one thinks of perspective in buildings – indeed most books, when illustrating perspective, use buildings as their example.

For boats the same rules apply as for buildings and you should study a work on perspective to understand fully this important subject. With a group of boats the vanishing lines created by the decks of the boats and waterlines ought to meet on the horizon. Thus if the deck lines and waterlines of all boats in a painting, such as the one opposite, meet at the horizon, the boats are in perspective. What is more they should all sit firmly on the water. Again the reduction in apparent size of the yachts in the distance provides perspective and a sense of depth to the picture, the length of the boats being foreshortened with distance.

The specialised aspects of painting tall historic sailing ships and the professional marine painters involved in that sector have already been mentioned. Occasionally one gets the chance to see such ships close to and such a chance occurs every year in Europe with the Tall Ships' Race. Fleets of tall ships, mainly youth training vessels from many countries in Europe and overseas, gather to race to several different ports.

Not long ago the race started in Plymouth, my home

port, and we were able to sail *Klondike Kate* around the fleet of tall ships. They were so impressive that they inspired some painting and sketching with the result that emerged above. The weather had been very sunny at the time but just as they were due to leave a mist and fog came down, hence the rather weak sun portrayed. My objective was to paint the grandeur and rather dramatic sight of the tall ship looming out of the watery sun with an increasingly misty background.

I started by washing the sky and sea with wet washes of Payne's grey and ultramarine, using yellow ochre to provide light and variety to the wash. The sun itself had been masked with fluid. The darkest sails were added using Davy's grey and a touch of raw umber and cobalt blue. The tone of these sails was critical to set the tone of the whole painting. Having established tones I filled in rapidly the other sails and hull taking care not to overwork the washes. The top masts and sails were faded out into the mist. Having completed the ship itself I added the reflections using loose brushwork and a No20 brush. Final details such as rigging and portholes were added, together with a few ripples on the sea.

As with so many other aspects of painting, the treatment of yachts and boats benefit from sketching practice. At the local harbour or marina, sit on the harbour's edge with a sketchbook on a sunny day and spend some time getting a better sun tan and better boats. Do some sketching of rowing boats or simple yachts from memory, get used to the basic form of bow and stern, the curve of the planking, the shadow underneath, the reflections and the way that different boats sit in the water. Look at them when the tide is out, note how they rest to one side, how the fishing boats when 'dried out' uncover their bilges and show the underwater shape – all of which helps you to understand the total form of the boat.

BEACHES AND PEOPLE

A most lively waterside location is the beach, with bright colours, lots of activity and strong light and shade. It is easy to sit with a small sketchbook and draw the children, donkeys, windsurfers and swimmers. Nowadays, particularly on Mediterranean shores, a life class may be thrown in with the topless beauties sunning themselves!

Drawing people in action is useful not only in beach scenes but many other waterside landscapes: fishermen mending their nets, oarsmen rowing or anglers fishing. The best way to develop your ability to draw people is to attend a life class with an experienced tutor who can demonstrate the effects of anatomy on different poses. For our purposes in this book, however, a few ideas on figure drawing can help to create reasonable impressions in your sketches and paintings.

A frequent mistake is that the head is drawn too big – it is better too small – the height of the figure is usually six or seven times the depth of the head and the shoulders are three times its width. Figures usually curve in movement. Limbs curve, clothes swirl and flap so that it

is difficult to find a straight line in a figure drawing of people in movement. Try emphasising the curves and a surprising improvement can appear. Try painting figures directly with the brush and without pencil drawing; in this way you are representing forms and not drawing outlines, which can help considerably. The same goes for lighting. It's amazing how much more realistic a figure looks when you show highlights on shoulders, top of the head or legs. You can either lift out the highlights or paint them using gouache white. Look at some old masters and see how a small figure is sometimes only a highlight and shadow, yet it looks remarkably realistic. Above all sketch, sketch and sketch some more. As with

On the Beach
Watercolour, 14×18in (36×46cm).
A study of figures in the waves, this sketch depicts children playing in the surf. A sketchbook on the beach provides useful practice for recording typical actions of swimmers or children playing.

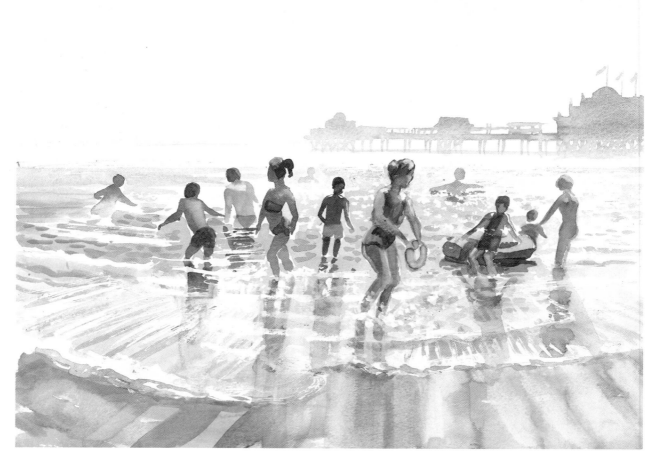

60

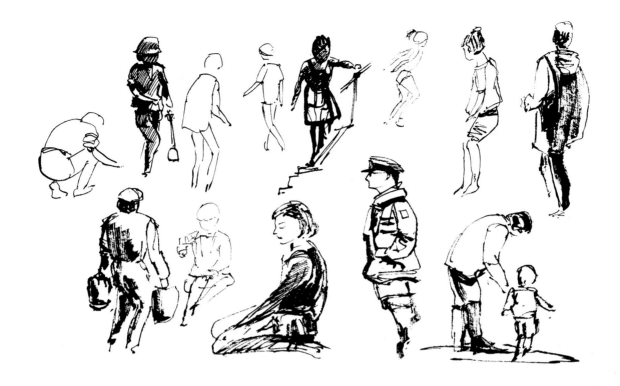

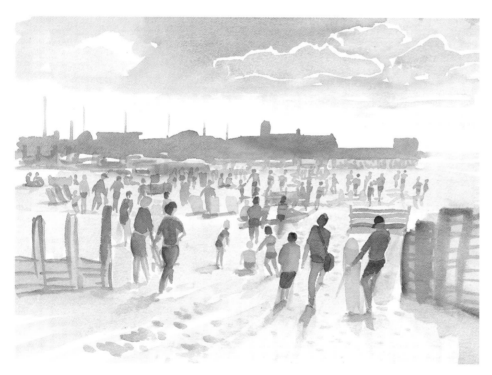

Beach Study
Watercolour, 12×16in
(30.5×41cm).
*Painted directly without
drawing, this study is an
example of the practice
which helps to develop figure
drawing with the brush. You
may find it more easy to
tackle figures directly with
the brush than by using a
pencil to draw the outlines
first.*

boats, figures can be useful in improving composition.

A figure can add focus or a spot of colour at a key point. Figures certainly add character to harboursides or waterside landscapes. If you are not fully confident in your figure drawing keep the figures in the middle distance. Often a spot of flesh colour will adequately repre-

sent the face without having to draw features. People in your paintings should also be in perspective. The further the distance, the smaller the figure becomes and make sure the figure fits into the rest of the painting – sometimes a figure is far too tall to go through a doorway which is next to it.

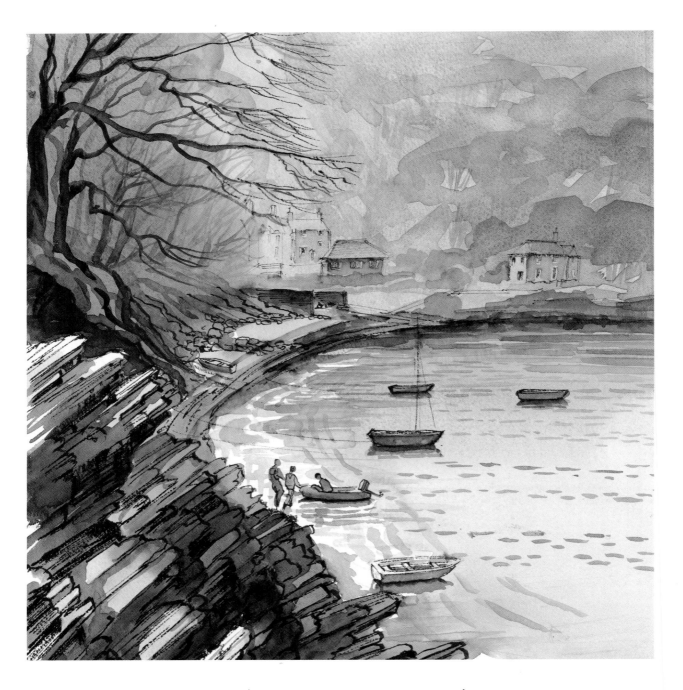

△ *Yealm Estuary*
Watercolour, 20×16in (51×41cm).
Rocks often feature in seascapes and should contribute to the composition. Here the rocks in the foreground help to provide interest and a dark tone to contrast with the lighter tones of the rest of the scene.

▷ *Cliffs at Sand Point*
Watercolour, 12×16in (30.5×41cm).
This study, painted directly with the brush on a sunny July day, explores the tonal contrasts between the cliff faces in shadow and the cliff tops and sea in sunshine. With an elevated viewpoint, the sandy colour of the water can be seen in the foreground and the reflection of the blue sky becomes apparent in the distance.

ROCKS AND CLIFFS

Waterside landscapes often include rocks and cliffs. In previous paintings of the sea breaking on cliffs or rocks, or mountain streams rushing over and around rocky banks I have used them as a major supporting feature. They are often a key feature of the composition and provide realism, context and scale to the waterside landscape.

In the painting opposite, the rocks provide a foreground of interest and the darker tones help to lead the eye to the lighter tones of shore and background beyond. As I have to walk up steps through these rocks from my moorings I know them well and they are a feature of the location. Rocks tend to follow geological structures which each have different characteristics. In this painting the layers of rock are very noticeable jutting out over the shore. In other cases rocks may be large cubical objects with square edges, or as with volcanic deposits, rounded shapes formed when the molten rock hardened billions of years ago. In the painting opposite the rocks have been painted with a large No20 brush using primary Payne's grey with some Davy's grey and Van Dyke brown. The detail of the rocks was added afterwards with black ink. This is explained further in a stage-by-stage diagram of painting rocks on the next page.

The painting below resulted from a walk taken on a warm summer's day along the cliff tops, carrying the minimum watercolour kit of a small paint box, two or three brushes, water and a 16x12in Bockingford 140lb pad. The main attractions were the light and shade, the colours and feeling in the rock faces.

Using a No20 brush I washed in the principal areas of colour with loose brushwork and wet washes. The sun's heat dried the washes quickly and using lemon yellow for the grass on the cliff top it was possible to achieve both tonal and colour contrasts with the cliff face below (ultramarine and Payne's grey). The browns used in the rocks were a mix of Davy's grey, umber and Van Dyke brown. I used black to pick out the cracks in the cliffs and the deepest shadows. The sea was washed in with some cerulean added to the raw umber/raw sienna mix – the reflection of the blue sky being greater on the sea in the distance, with the colour of the water and shore being more noticeable in the sea in the foreground. The water in this case was a yellow-brown colour as it was part of a tidal estuary. The foreground grass was rapidly washed in leaving an impression of flowers and plants on the cliff tops. A fresh watercolour sketch had resulted after an hour and a half – which made that sunny walk even more enjoyable.

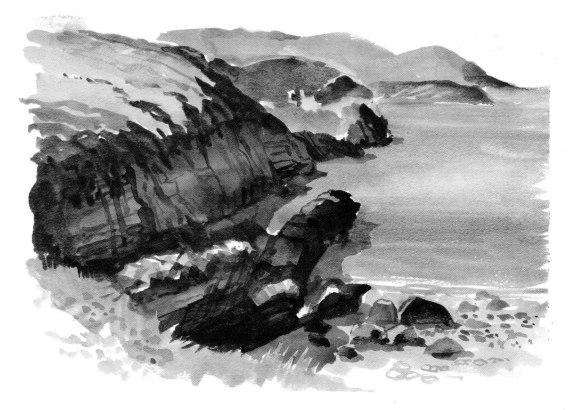

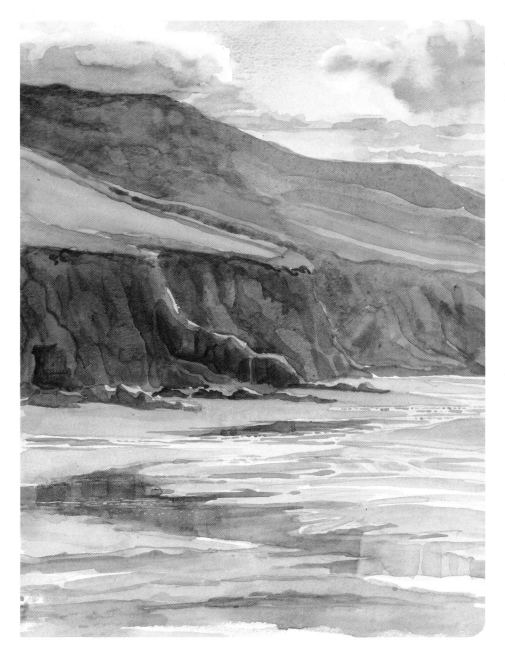

Cornish Cliffs
Watercolour, 16×12in
(41×30.5cm).
The cliff face was painted by overlaying washes using Davy's grey, raw umber and Payne's grey, thus producing a soft luminous pattern of shapes and edges.

Whereas the previous painting was from the cliff top looking down, the painting above was from a position on the beach. This was painted some years ago on a family outing while my daughters paddled, caught shrimps and otherwise enjoyed a late summer's day at the coast.

The cliffs are described using overlays of colour to create different planes and rock faces. The light was towards me creating highlights on certain edges of the cliff, the colours of the cliff face being mainly Davy's grey and raw umber. The reflections in the water on the beach add interest to the foreground. Figures, or maybe a small sailing dinghy with a red sail would probably complete the picture more fully.

An easy approach to painting rocks is demonstrated above. An initial wash has shadows added and then is overdrawn with either paint and brush or ink and pen indicating the cracks in the rock and the shapes of planes or humps in the rock's surface. Lichen or moss on rocks can be added with spots of colour. The reflection is painted as previously described but frequently, when looking down on to rocks, the reflection will make the underside of the rock much darker than the visible portion. Rocks in fast-flowing rivers are usually worn smooth by the water and are less cracked and jagged than those on the shore.

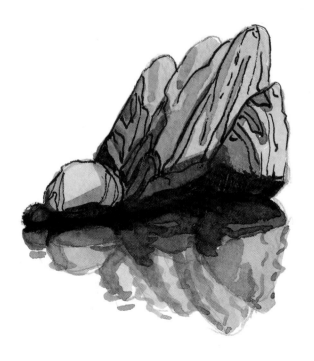

Sketching Rocks

In this stage by stage illustration the rocks are first drawn in pencil, then the colour of the lightest areas is washed on followed by the initial tone to create shadows. A second darker tone is added. Finally, pen can be used to describe cracks in the rock. Note how the reflection shows more of the underside of the rocks and uses a reduced tonal range.

SKIES

In waterside landscapes skies often play a crucial role in setting atmosphere, time of day and weather. The style of painting used in the sky needs to relate to the overall style of the painting. A loose fresh sky needs to complement a loose fresh painting. Sometimes it is possible to wait until the conclusion of your painting to add the sky and thus balance various elements in the rest of the painting by the way you paint in the sky. This is certainly the case in oils and acrylics but in watercolours you often have to paint the sky first to avoid problems at the horizon or where trees, say, project across the sky. Watercolour artists often set the mood and style of a painting by painting the sky first and then completing the picture to complement the sky. Certainly the sky should be an integral part of the picture, not a standard blue wash or an afterthought.

The clouds should play an important role to balance the composition – a large cloud to one side offsetting some imbalance in the landscapes. The lighting of clouds must be consistent. A side-lit cloud should match a side-lit composition. Sometimes you will see an unforgettable scene as shown below where the sun shone a ray of light through very dark storm clouds which just caught the steam from a moored naval ship. Try to assess the different colours, tones and lighting that relate to different times and seasons. The painting opposite has high key tones and warm summer colours to set a light, warm atmosphere to the beach scene.

In watercolour painting the technical aspects of painting skies are critical. The softness of clouds, mist and haze, or the gradated colours and tones from horizon to overhead requires a skill in handling washes.

We have seen already in Chapter 1 how still water and clear skies can be handled with washes. The examples on this page show a wet in wet approach to painting clouds. You should sit in your studio or wherever you paint, look out of the window and practise painting clouds.

Try different shades of blue, mix the blues with crimsons or yellows or greys and use different brushes – the larger the better – try smudging the wet grey-yellow

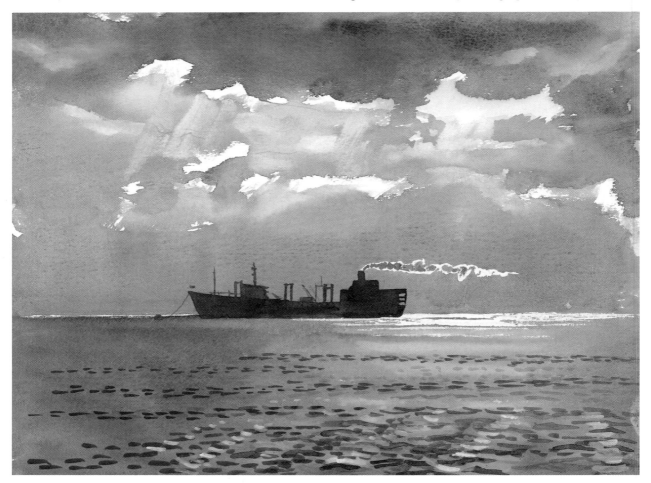

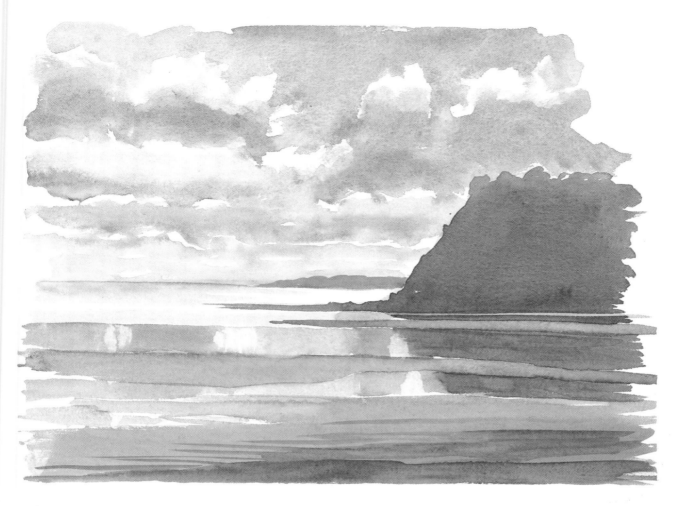

△ *Cloud Study*

Watercolour, 12×16in (30.5×41cm).
*A delicate study of summer cumulus
clouds over the sea. The method of wet
in wet cloud painting is described overleaf.
The colours and high key tones of this
study gives a summery feel to the
atmosphere.*

◁ *At Anchor*

Watercolour, 12×16in (30.5×41cm).
*A dramatic atmosphere is created by
dark skies, with backlighting, and a
similar dark reflected colour for the sea.
The sky is painted using wet washes with
some lifted edges. It is well worth
experimenting with extremes of tones
(tonal range) to assess the dramatic
results which can occur.*

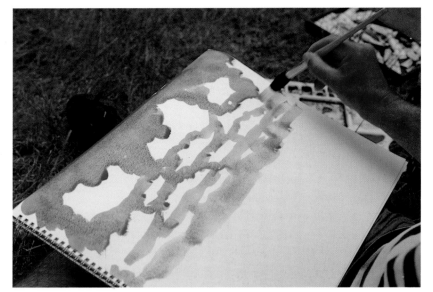

CLOUD STUDIES
Stage 1
A well-loaded brush (a medium Pro Arte Series 320 with a rounded shape) is used to wash on ultramarine/colbalt blue leaving white paper for the clouds; towards the horizon some crimson traces are added.

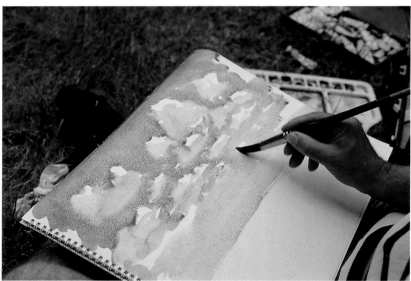

Stage 2
While the blue wash is wet, Davy's grey and yellow ochre are quickly painted in to form shadows in the clouds. The shadows merging with the sky under the clouds were painted in using a No 20 pointed brush, wet in wet.

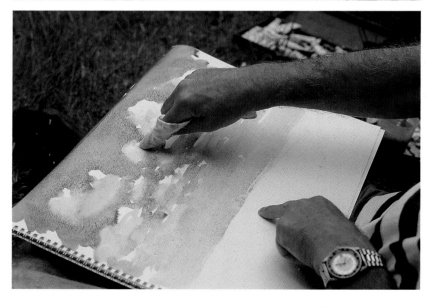

Stage 3
While sky and cloud shadows are wet the top edges of the shadows are rubbed with a rag to soften them, sometimes also softening the edges between cloud and sky.

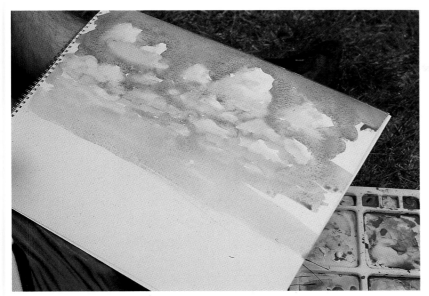

Stage 4
The paint is allowed to dry and areas requiring touching up are identified.

Stage 5
The final stage with an example seascape added. The whole process has to be handled quickly, the example being painted on a hot day in a matter of minutes.

shading of clouds into the white plain paper with a wet rag. Hold the paper at different angles, try different rates of drying with a hair-drier and experiment with different types of paper surfaces: rough, smooth, rag-based, artboard, and so forth; introduce some gouache white, or masking fluid. The more you experiment the more you will understand how paint behaves and the better you will be able to paint skies to match whatever your picture requires.

Paintings with low horizons are often nothing but cloud studies. The artists in Holland or East Anglia – no doubt also in the prairies of Canada or the USA – have totally flat landscapes requiring the sky to be a fundamental part of their pictures. John Constable painted studies of skies continually, many of which can now be seen in galleries or museums. He knew that in his East Anglian landscapes the clouds and skies were critical to a successful depiction of the local scene. Look at the more recent paintings of the Norfolk coast by Edward Seago. Much of their popularity depends on the bold way he painted clouds and passing storms, often with a low horizon and fishing boats pulled up on a shingle beach.

4
Lakes and
Rivers

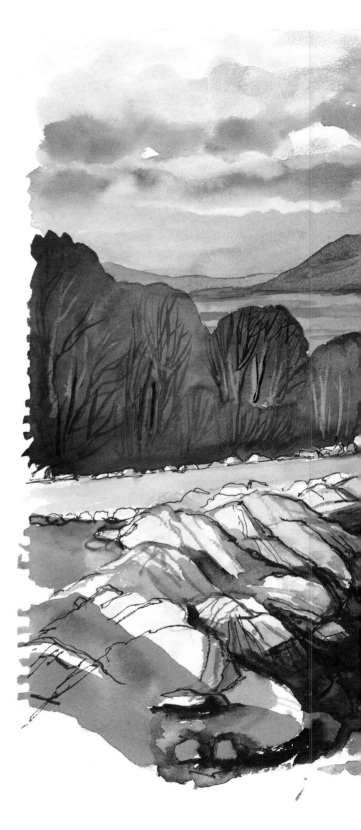

Much of the enjoyment in painting lakes and rivers comes from the landscape surrounding the water. From the mighty snow-covered Rockies to a small leafy woodland, the surrounding landscape provides a wide variety of subjects for the waterside painter. However, the lake or river should remain the focus of the waterside landscape. Much of your concern has to be to capture the mood and character of the environment. If the lakeside is in Italy try to choose a subject which has an Italian flair about it. If in the Rockies choose a position where the magnificent rock faces unique to those mountains are much in evidence, or if the subject is a mountain river in the English Lake District try to capture the character through the small stone bridges, woods and mountains.

Previously, I stressed the importance of movement and action in depicting ocean waves or beach scenes; lakes generally tend to be more placid and calm, more atmospheric and moody. Nevertheless, rivers and lakes have active sporting elements such as the rowing skiffs, water-skiers, or anglers. A roaring waterfall crashing over a ninety foot precipice has much of the awesome power of the ocean surf breaking on to a coastal cliff.

Life on the water can be fascinating. Colourful canal boats moving through the countryside are often directly related to the last century when families lived and worked in the tiny accommodation of canal barges. Usually they are brightly decorated with their own unique folk art. The lake steamers and ferry boats, or the traditional American river boats inspire some artists who love to capture the tall funnels belching smoke as the boats make headway with paddle wheels thrashing and white wakes streaming behind.

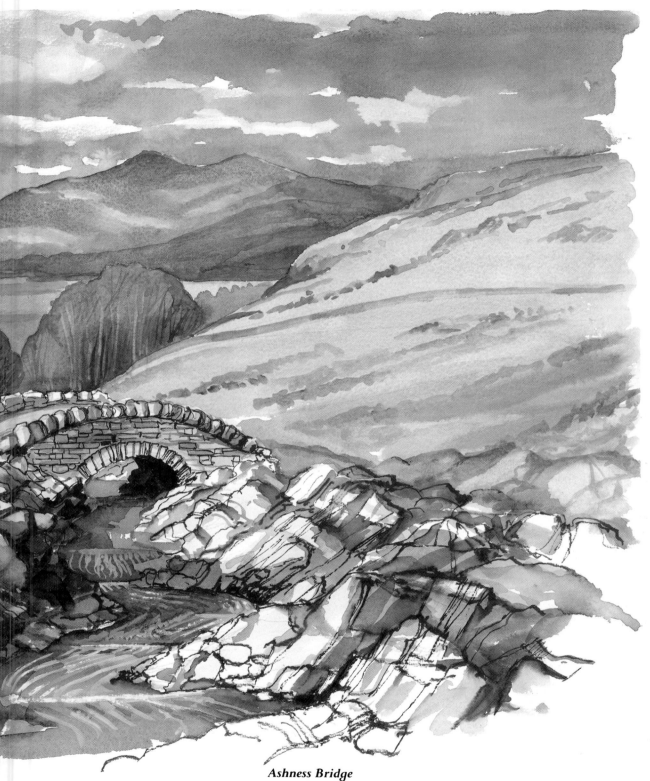

Ashness Bridge
Watercolour with Pen, 16×20in
(41×51cm).
*This waterside landscape encompasses
both river and lakeside views. Note how
a pen-and-ink outline has been used to*
*describe the foreground rocks and bridge
and has also helped to create the aerial
perspective needed in the picture, with
strong tones in the foreground and
reduced tones into the distance.*

LAKES

Land-locked lakes are invariably ideal locations to paint still water. The mountains and lakesides reflected in the water create atmospheric environments to be expressed in watercolour or other media.

I feel that watercolour is particularly suited to catching the damp, still atmosphere often seen from the lakeside. The wet wash in sky, mountain and lake perfectly captures the ambience. At the lakeside by the water the full effects of reflection predominate, with perhaps thin streaks of light where a local breeze ruffles the lake's surface in the distance. Looking down on the lake from higher up the mountains creates different lighting again, and less dominant reflections.

The painting of *Lake Maggiore*, below, shows the view from the harbour front of Ascona near the Swiss/Italian border. I chose the view to capture the snow-covered mountains and the headland to the right which has local Italianate houses with their delightful washed walls of yellow ochres, pinks and greys. After an outline drawing I started with the sky and mountains keeping the white paper to represent the lightest snow areas, and ensuring that the tones of the shadows were not too heavy as I wanted the aerial perspective to create distance behind the headland. Using cobalt and cerulean for the sky the shadows under the clouds were added with Davy's grey and yellow ochre, using the technique described earlier.

The shadows on the snowy peaks were added in cobalt blue and the lower slopes were painted in ultramarine and crimson alizaron, with final touches of Van Dyke brown/Payne's grey for the tree-lined base to the

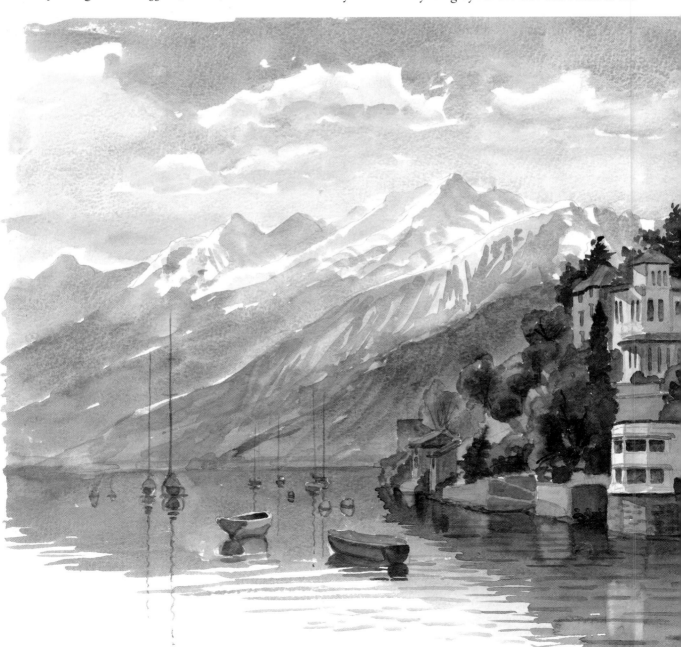

△ *De Witt Clinton, New York*

Watercolour, 12×16in (30.5×41cm).
Fascinating lake steamers have existed over the last century or so. This example based at the South St Seaport Museum in New York is used for sightseeing trips. A pen-and-wash study enables details of the boat to be easily handled.

◁ *Lake Maggiore*

Watercolour, 14×18in (36×46cm).
Lakes provide wonderful settings for a waterside landscape. In the Italian lakes, this view encompasses the cool snow-peaked mountains with the warm foreground colours of spring. The tonal relationships of mountains, lake and foreground need careful assessment.

mountain. The lake was washed in with an ultramarine/crimson mix, carefully relating the tones between lake and mountain. The headland was painted next, the greens being a sap green mixed in various proportions with ultramarine or Payne's grey and the houses being primarily yellow ochre diluted with crimson and cobalt blue. I tried to capture the light falling across the faces of the houses. The reflection of the headland was washed in using a sap green/Van Dyke brown combination, taking care with the tonal relationship to the headland. While wet, some reflected highlights from the white building and lakeside grass were lifted out. Some lines of ripples were added and finally the boats and their reflections were touched in. Note how the relatively warm colours of the headland offset the cool colours of the mountains.

I enjoyed painting this picture. I sat on a small jetty with no interruptions. The weather was consistent and the view delightful. The result felt right in that it conveyed the atmosphere and local identity of Ascona.

Many, many miles from Lake Maggiore can be found the river steamer *De Witt Clinton* at the South Street Seaport Museum in New York City. This boat is in regular service taking tourists on trips around the harbour and it made a delightful subject for a sketch, with its links to the early days of the Mississippi or other great rivers of the past. I used pen and wash better to describe the details and structure of the topsides of the boat; broad washes were used for the sky and the smoke from the funnel. A simple jetty completed the painting.

Still on the North American continent the drama of the Rockies is a daunting subject for the artist. In this painting the lake is used to add interest and a baseline to the picture. It is worth practising painting mountains as they often form the background of some spectacular lakes around the world. In this case the Rockies needed to be painted emphasising the immense cragginess of their sheer faces. I decided that the most direct way would be to outline the snowy lines in masking fluid, washing on the grey rock colours before removing the fluid and adding cobalt blue for the shadows in the snow.

The greys used were Davy's grey with Payne's grey, emphasising the shadows and rock faces. The wooded lower slopes used sap green, Hooker's green and Payne's grey, the colours and tones being varied to suggest light and shade created by the small clouds passing across the sky. The tall fir trees in the foreground help to offset the strong horizontals. My original small sketch for this picture was painted in the Kananaskis Park close to where the Winter Olympics were held in 1988. The sharpness of the features of the Rocky Mountains are in very different mood from the soft colours and undulations of the mountain slopes of Lake Maggiore on the previous page.

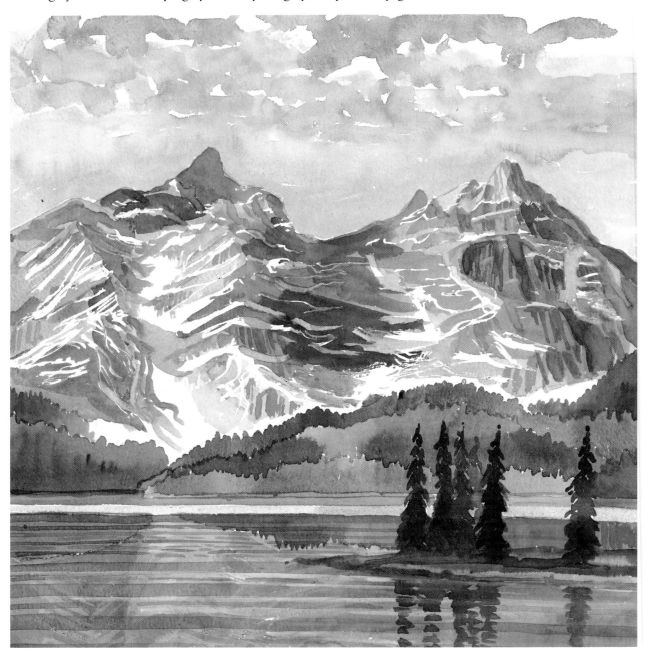

▷ *Italian Lakeside Village*

Watercolour, 20×16in (51×41cm).

The foreground rooftops create an unusual but interesting character to this painting and establish the Italian origin of the view. The pen lines create a texture of tiles and brickwork, and were added on top of the watercolour painting.

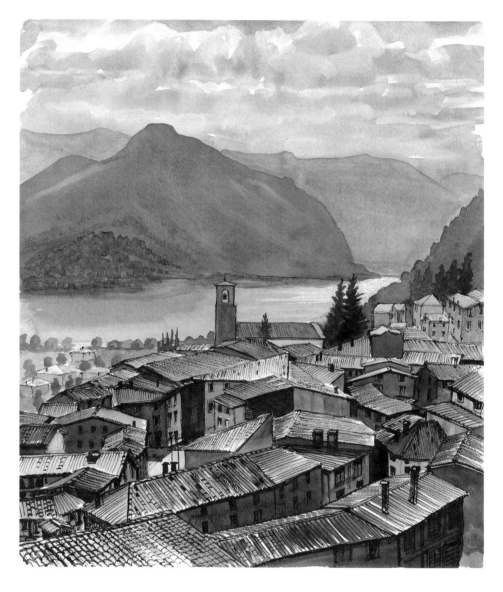

◁ *Rocky Mountain Lake*

Watercolour, 16×14in (41×36cm).

With a spectacular backdrop to the lake, this painting is more about the granite faces of the mountain with the snow lines etching the patterns of the cliffs, than it is about painting a lake. Often with lakeside views, the water provides an interesting foreground to complement a dramatic landscape.

Returning once more to Italy, the painting of the lakeside village has used the foreground collection of rooftops to make an interesting painting, with local identity coming from the Mediterranean-style architecture. The softly wooded mountains provide a backdrop with the lake adding light and local identity in the middle. Note how the lake is used to silhouette the foreground buildings. An italic pen with black ink was used to outline the architecture, drawn on top of the watercolour painting.

The choice of viewpoint and subject has varied in the pictures of lakes so far: down by the water's edge, up in the mountains above a village, facing the Rockies. There is tremendous scope for a variety of subjects by lakesides.

Not only can a wide variety of lakeside landscapes be found such as the Rocky Mountains or the Italian lakes but one lake can have many moods as the weather and seasons change. This is particularly true in the mountains when mist clouds drift across halfway up the mountain side or streaks of sunshine create pools of light at various points on a lake.

As clouds move across the sky, so their shadows move across the mountains and lakes giving great scope for variations of tone or colour across the picture. Many years ago, having committed myself to a weekend painting in the English Lake District, I arrived in heavy rain which continued all weekend. However, sitting in my car high above the lakes, I saw that in spite of the low light levels, as each heavy cloud moved across the landscape so the tones changed and as heavy rain came and went the mountains appeared and reappeared. The painting I did that day was one of the best that year and sold immediately in the local gallery. The next day – rain again – but in a car park looking over a lakeside village the wet glistening roofs provided an interesting and attractive foreground to the dull, rain sodden lakes and hills. Another good picture resulted. To many people the English Lake District would not be the same without the mists and rain. In the gallery one is attracted by a picture which reminds one of the reality of the Lakes, not an advertising image of blue skies and hot sunshine.

The painting to the right quickly painted from the window of a house high above the lake catches the retreating storm clouds after an unexpected snow fall. With clouds slowly lifting and revealing the mountains above Locarno in Switzerland the light had just started to shine on to the lake and the mist was slowly evaporating up the sides of the mountain. The joy of seeing the storm passing motivated me to pick up brushes and watercolours and try to capture the scene quickly before the view changed totally. The mountains were washed in using a mixture of Payne's grey, ultramarine and Davy's grey. Leaving spaces for the clouds which were loosely added with Davy's grey and yellow ochre, I lifted out some patches of mist from the left-hand mountain side.

I added the foreground peninsula in the lake, darker in tone to create the aerial perspective, and varied in tone, texture and colour to represent trees, buildings and open spaces. The nearby foreground houses had snow on their roofs for which I used the plain paper, chimneys were indicated very loosely and finally local tree branches were suggested in Van Dyke brown/black mixtures. Very quickly done, this sketch nevertheless caught the light and misty feeling of the departing storm.

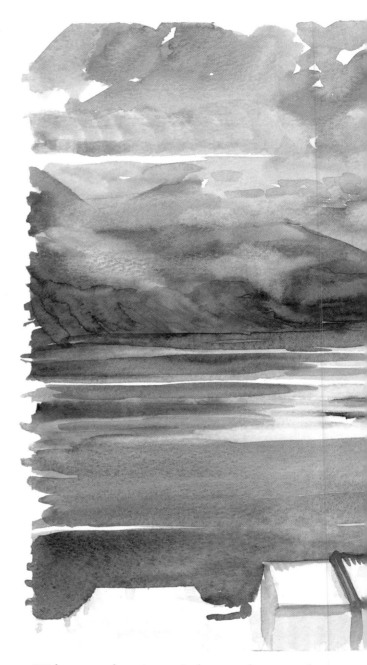

With watercolour in particular, you have to take chances to capture fleeting effects. Often it is the 'controlled accident' which produces the breakthrough. Have a go with a very wet wash, add extra colours or change the angle of the paper halfway dry, smudge the edges with a dry or wet cloth, drop in some black ink – wash off under a tap and start again. There are various exponents of the controlled accident, or multiple working school. These are led in the UK by John Blockley who has produced some great interpretations in watercolour by repeatedly reworking the paint using novel approaches. He has outlined his approach in several books.

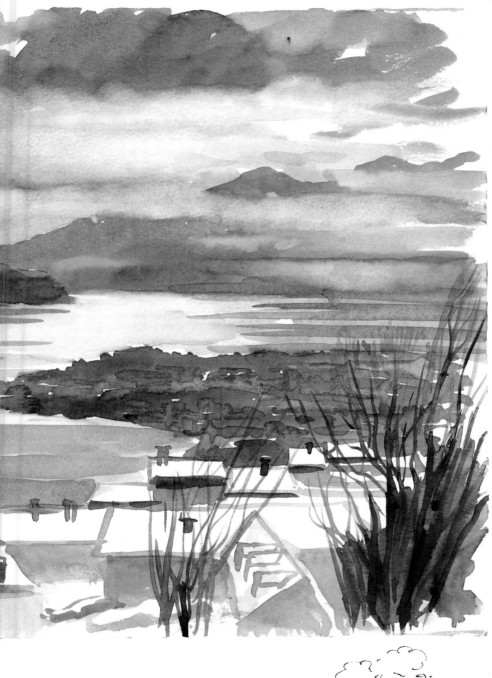

The Passing Snowstorm
Watercolour, 12×16in
(30.5×41cm).
*Lakeside painting often
requires the interpretation of
atmospheric effects, from hot
and still summer days to the
more dramatic, cloudy scenes
of winter and spring. In this
watercolour the wet in wet
treatment of clouds
predominates, with a
suggestion of foreground
rooftops covered in snow.*

RIVERS

As with lakes, rivers provide an enormous range of landscape options, from the sparkle of a rushing stream through rocky tree-lined banks to the stately progress of the wide river through soft rolling hills. Rivers curve and snake their way through the landscape. The curving banks often make a pleasing subject and a useful composition device, enabling you to lead the eye into your picture through a curving river rather than with a boring straight line.

We have seen in previous chapters how to paint still or moving waters. Rivers often look more interesting if you can combine elements of both still and moving water in the same picture.

In the acrylic painting below the still waters of the river in the bend of the river reflect the trees on the bank, while the rapidly flowing midstream appears sparkling white in the sunshine. My interest in this picture was the dramatic contrasts looking into the light with silhouetted figures, trees and rocks against the intense light of river and sky. The figures added a focal point of interest and colour with the additional pale blues and purples of the background woods providing a contrast to the predominant browns and greens. Using small brush strokes with individual dabs of colour I was

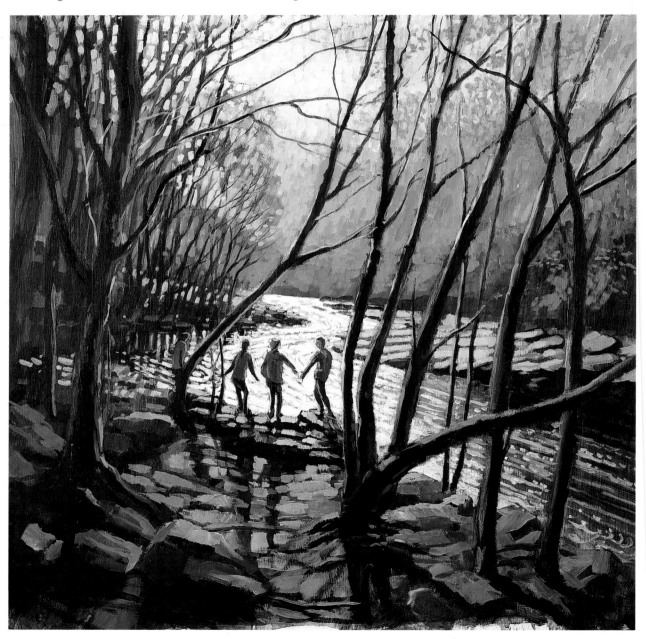

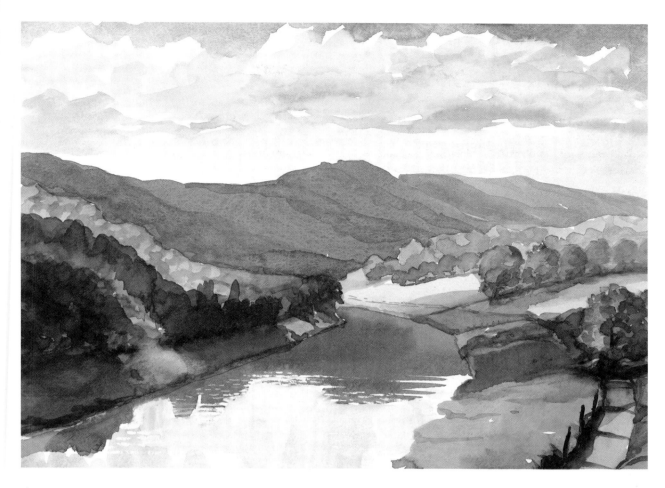

△ *Wye Valley, Wales*

Watercolour, 16×20in (41×51cm).

A soft summer's day in the peaceful Wye Valley contrasts with the previous acrylic of the winter sunshine. The gentle curves, soft colours and still-water reflections all contribute to the calmness in the painting.

◁ *Winter Sunshine*

Acrylic, 36×36in (91.5×91.5cm).

The bright reflected light from a low winter's sun is used to silhouette figures and trees in this mountain river picture. The acrylic has been applied with individual brush strokes creating an effect of shimmering light with the skeleton of tree branches against the sky providing a pattern of light and dark.

able to suggest the effect of light coming through the branches of the trees.

What a contrast the watercolour above provides, depicting the wide sweep of the Wye Valley in Wales with the soft green landscape and tree-lined slopes of the mountains. The composition is very simple; there is not a lot of specific interest in the painting but a feeling of peace and tranquillity seems to be emitted from the scene. The water is simply treated as a still calm stretch with an impression of reflection and ripples in a simple wash. Variations of light and shade in the valley add some variety but overall the success relies on the impression provided of a stately river in a beautiful valley.

Seasons vary on the river bank. The fresh light of early spring with bare trees and little colour is shown in the watercolour above. The freshness has been suggested by leaving much of the sky as white, unpainted paper. The water in front of the bridge ruffled by wind is also white paper. Parts of the river are calm, providing reflections of trees and bank. The bare trees and brown washes of bushes and trees in the background all indicate early spring before the grass and flowers respond to warmer weather and burst into colour.

The composition of the watercolour above is highly symmetrical, something which normally does not work well. The trees to the right help to provide interest and add depth to the painting by being much stronger in tone than the trees behind and bushes to the left of the bridge. I started the painting by completing the bridge first, then the background hills, leaving a white highlight on the top of the bridge. These initial tones set the range for the final picture. Looking into the light provides interesting tonal contrasts and is well worth attempting.

The acrylic painting top right *By the Windrush* depicts the warmth of a summer day, the sun high overhead and

River Avon, Hampshire

Watercolour, 12×16in (30.5×41cm).
A bright spring light is captured in this 'into the sun' painting with silhouetted bridge and trees. Great care in assessing tones is needed with this type of lighting.

two boys lazing on the small bridge. I painted this picture on an underpainting of a neutral grey which reduced the glaring white of the priming. The day was very hot and the effect of the sun shining on to the board was a problem. The grey underpainting helps to cut the dazzle but the resulting picture always seems a little dull in colour and tone which I feel is the case here. The high overhead sun is suggested by the shadows under the trees and the highlights on the figures. The bright yellow cornfield not only emphasises summer but provides interesting silhouettes of tree trunks and fences. I painted the reflections using small vertical brush strokes to suggest water with the blue reflections of the sky providing a strong element of realism to the whole reflection.

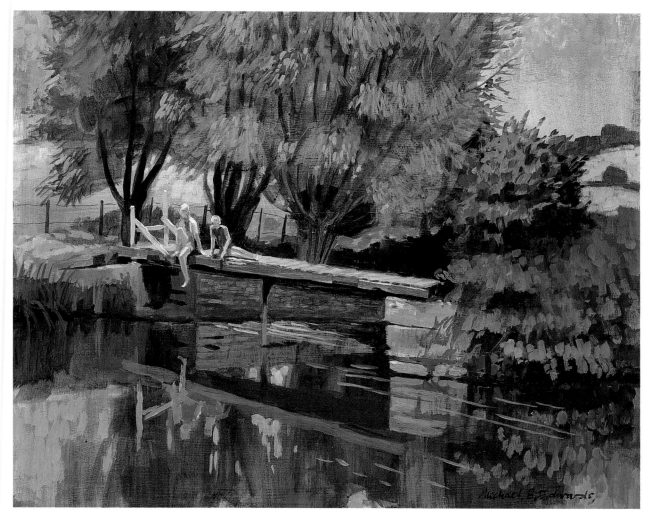

By The Windrush
Acrylic, 16×20in (41×51cm).

River in Spate
Watercolour, 16×12in (41×30.5cm).
*Very different in character, the painting
of this turbulent river uses similar
techniques to those for moving water
described earlier. Note how the dark
foreground helps to create depth in the
picture.*

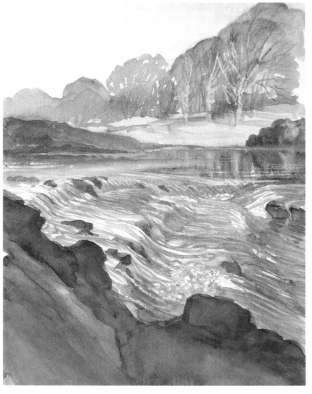

The river was flowing very gently with no ripples and the
stillness of the water helped to give the atmosphere of a
very hot and still midsummer day.

A totally different atmosphere with the river in full
spate is shown bottom right. Here the linear technique
follows the water on its path rushing down the rocky
bed overflowing its normal route. The rocks curve into
the picture with a dark foreground helping to increase
the apparent light tones of water and background.

Clifton Suspension Bridge
Acrylic, 15×21in
(38.1×53.5cm).
Bridges provide valuable subject matter in riverside paintings whether it is a grand suspension bridge such as in Bristol or a humble wooden footbridge in the sketch below.

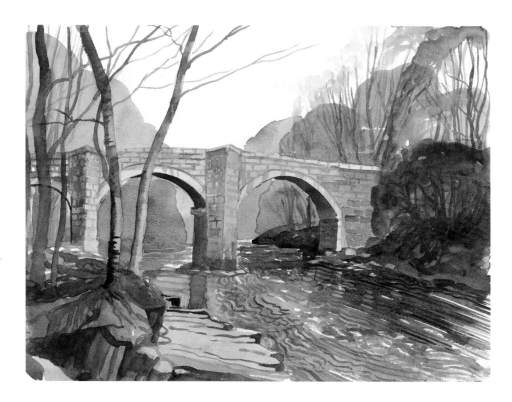

Dartmoor Stone Bridge
Watercolour, 14×18in
(36×46cm).
*Typical of the stone bridges
on moorlands in England,
this bridge over the River
Dart, together with the
rippling waters of a fast-
running river provides an
elegant subject. The
stonework creates interesting
patterns and texture and the
harmony of the colours of
the background trees and the
bridge bring a cohesion to
the scene.*

BRIDGES

One of the most useful contributors to a riverside land-
scape is the bridge. It provides the perfect focus of the
composition; it can add character and distinction and an
idea of location. The elegance of the suspension bridge
cannot be matched, particularly in the case shown left
where the Clifton Suspension Bridge leaps across the
Avon Gorge, 250 feet above the water. With Georgian
houses in the long terraces staggered up the hillside this
Bristol scene is very famous and attractive. The acrylic
painting uses a grey base and underpainting which still
shows through in the water and elsewhere. A winter
scene, with low afternoon sunlight from the left, the
snow is used to add light touches, which enliven the
picture.

The humble footbridge in the sketch below also offers
a worthy subject, its straight wooden beams contrasting
with the curves of trees and river banks. The bridge will
often provide scope for reflections and shadows in the
water adding to the sense of light and depth in the
waterscape.

The stone bridge, as shown in the watercolour from
Dartmoor, can be a delight with beautifully constructed
symmetry and mellow weathered stone. One marvels
how these bridges were built and wonders how long
they will survive the weight and frequency of modern
traffic.

In this picture the light on the bridge emphasises the
stonework which contrasts with the dark surrounding
water and trees. The stonework is detailed identifying
individual stones picked out in brown or grey on the raw
sienna and Davy's grey underpainting. The low view-
point and horizon dramatises the bridge outlining its
elegant yet sturdy arches against the background sky and
trees. Note how certain stones in the bridge are outlined
and others painted in solidly; this gives variety to the
stonework. The water follows the process described in
Chapter 1 on moving water. In this case, the water was
turbulent with touches of white water and sparkles of
reflections. The dominant colour was dark blue (ultra-
marine) which in the picture works well in that it con-
trasts with the browns and yellows which are the
principal colours of the rest of the painting.

I painted the bridge first not only to obtain the fresh
and bright colour for the stonework, but also to set the
tonal range as the darkest dark in the painting was under
the arches. I painted the background trees and banks
next using raw sienna, Van Dyke brown and Payne's
grey, then the water was added. Note how the still water
to the left helps to show the reflection of the central
column. The colours in the water are ultramarine and
Hooker's green together with reflected colours of Van
Dyke brown and Payne's grey for the trees. I used
gouache white to add some of the foreground eddies.
Finally I added the foreground trees, bank and rocks.

CANALS

At first sight canals may appear to be straight rivers without the attractions of waterfalls, mountain rocks and rushing waters, yet they have their own fascination. They pass through city centre and countryside alike, often with industrial architecture of a different century as a backdrop. The canal boats are unique with long narrow construction, bright colours and smoke pouring from the tall narrow chimneys of the older boats. The people who used to work the boats in England lived in tiny cabins which were scrupulously clean and highly decorated. They were a tight-knit community whose history is now chronicled, complete with old sepia tint photographs and it makes fascinating reading.

For the painter there are additional subjects of lock gates and lock-keepers' cottages and the folk-art decorations of the boats and utensils all contributing to the artistic opportunities in the canal scene. The paintings below and to the right reflect two very different locations. The acrylic is a winter scene near the heart of the city of Leeds, where the remains of a once-bustling canal port form a backdrop for a solitary boat in mid-winter. The attraction of the scene for me was not only that I could paint from my car on a cold day but that the colours of the buildings and surroundings gave the feeling of old smoke-tarnished brick and stone. I used raw umber tinted priming on the board, to provide a warmth to the final picture. I painted a monotone outline of the whole picture in raw umber using a ½in flat soft brush (606 Sceptre). I then added the brickwork and details to the buildings on the left introducing burnt sienna, red iron oxide and Paynes's grey, and painted the bridge in raw sienna/titanium white. The water was treated in an impressionist way of small blobs of cobalt blue and yellow ochre on top of the raw umber initial monochrome outline. The sky was painted with soft colours and edges using square brush strokes, introducing a purple colour near the horizon to act as a complementary colour to the yellow stone of the bridge. With a low winter sun casting cobalt blue shadows across the snow, the aim was to portray a soft late-afternoon scene in this northern city.

In complete contrast the watercolour, right, expresses a summertime trip down the Wey Navigation Canal in Surrey, the whole emphasis being on the green foliage lit

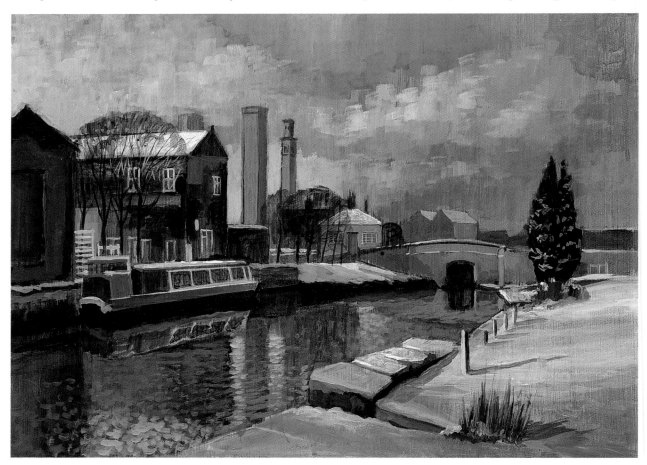

The Wey Navigation Canal

Watercolour, 12×16in (30.5×41cm).

Of great contrast to the winter scene opposite, this watercolour uses a cadmium yellow underpainting to infuse the sunlight into the total painting.

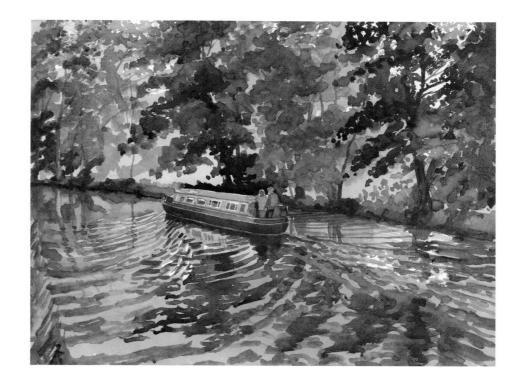

◁ *Leeds Canal Basin*

Acrylic, 18×24in (46×61cm).

Canals provide a variety of waterside landscapes from the historic industrial architecture of a northern city to the leafy stretches of tree-lined waterways. This acrylic was painted using an underpainting of raw umber and yellow ochre which together with the burnt umber used in the buildings, provides a warmth to the painting in spite of the snow.

by a bright summer's sun reflecting in the water. Background washes of sap green and lemon yellow were first applied leaving one or two spots of plain paper. Subsequent leaves were applied quite wetly using sap green, Hooker's green or Van Dyke brown, similar colours being used for the ripples on the water. The leisurely holiday cruise on a converted narrow boat has quite a different atmosphere from the cold industrial canal in Leeds.

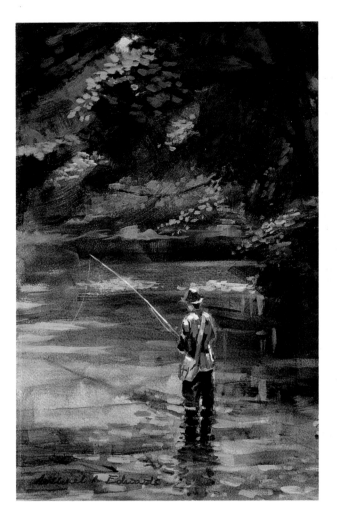

ANGLERS

One of the most popular sports in many countries is angling. Like the leisure painter, the angler enjoys the quiet beauty of a waterside location testing his skill to the background sounds of the flowing stream and the song of the birds.

No doubt the angler sometimes struggles hard to capture the fish, as we might struggle to capture the beauty of a scene. The angler's efforts, when added to our painting, create interest and focus, adding sometimes movement, or at other times an extra element of composition. The resulting painting can be attractive to a specialised market sector – I have found that fishing pictures usually sell very well in galleries. Observation is valuable. The coarse fisherman, sitting still for hours watching his float, is perhaps less of a challenge than the fly fisher who somehow floats his line through the air to land precisely where and how he has planned it.

Sketches of such anglers can help to understand more about the action and I am fortunate in having a friend who is a keen angler and quite happy for me to sit sketching his efforts. In the acrylic, left, the angler provides the focus of interest in this quiet green corner of a river in Devon. Although I felt the figure to be rather still and static, my angling friend assures me that I have caught the pose correctly. The background was brushed in freely using a ¾in flat nylon brush with Hooker's

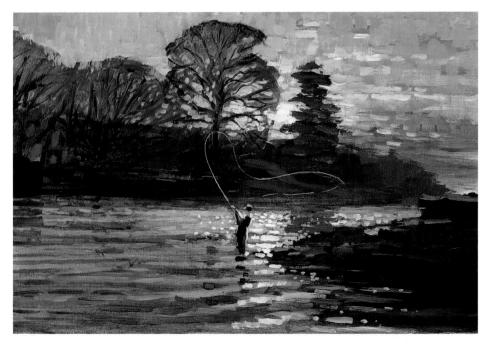

Casting for Salmon
Acrylic, 12 × 14in
(30.5 × 36cm).
An evening scene with a wind rippling the waters, the essence of this painting is the light in the sky and on the water.

Opposite
Fishing on the Barle River
Acrylic, 20×14in (51×36cm).
*Anglers provide a useful subject in river
paintings — they also provide a good
market for the sale of fishing pictures!
This coarse fisherman is concentrating
hard on his float in the quiet waters of
calm river in Somerset.*

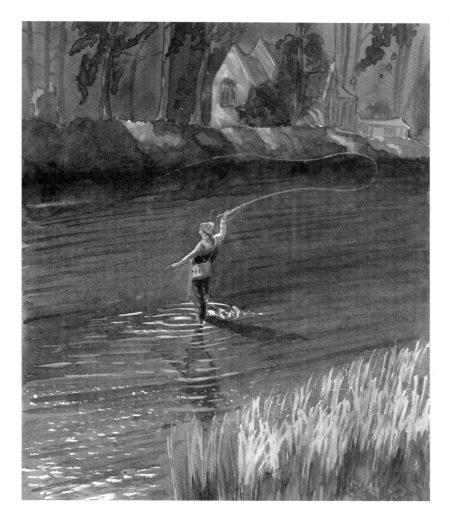

▷ **Flyfishing on the Usk**
Watercolour, 18×14in (46×36cm).
*The wide, shallow waters of the Usk
provide a range of habitats for fish and
fishermen alike. Here the light catching
the ripples creates a focus on the figure
with the background church and river
bank giving a clue to the location of this
scene.*

green/lemon yellow. The water was painted using raw
sienna and raw umber washed thinly on to the primed
canvas. Anglers usually wear colours to blend in with
their surroundings, creating a warm, soft image.

Very different is the small acrylic below, of a fly
fisherman in the late afternoon on a winter's day. There
is a cool breeze sending ripples across the water which
catch the sun's rays. This painting is as much about light
and reflection as angling. The cool blues and greys
(cobalt and Payne's grey) adding to the winter feel
created by the bare trees. The fishing line was scratched
into the paint with a sharp point.

The watercolour above shows my friend Peter in
action on the Usk river in Wales. At this part of the
river, wide shallows enable him to wade out into the
river, the ripples catching the light. A dark background
of bank, trees and small village church tends to em-
phasise the figure. The water was washed in with sap
green, and a subsequent wash of raw umber was added
to provide a variation of green and brown, reflecting the
colours of the riverbed.

WATERFALLS

Waterfalls have a great attraction to tourists, photographers and painters. The sparkle, movement and powerful roar as the water crashes hundreds of feet down a mountainside, create a tremendous spectacle. You may feel that to capture all of the elements of a waterfall is too demanding but by simplification it's possible to reduce the problems substantially. Most waterfalls are white water. To portray it you have to either leave plain white paper or use masking fluid, gouache white or some other opaque white paint. The challenge is to make the water look as though it is flowing and falling in the waterfall. Much has to do with shading, and the play of light on the water.

In the small waterfall on the left the acrylic painting depicts a small stream cascading over rocks in the woods. The waterfalls themselves were drawn with lines of white paint, the shading on the water falling vertically was a wash of dilute cobalt blue or Hooker's green, mostly the former. The attraction of the scene to me was the light and shade coming through the trees picking up the water here and there as it poured over the rocks.

In watercolour I use a very similar process with lines of cobalt blue painted on to the white water to represent the flow and the shadows across the water. In the painting opposite the brown of the rocks was visible through the waterfall towards the bottom. I also used gouache white to add some broken water at the bottom and to touch up parts of the waterfall itself. The brown and green of rocks and ivy with dark tones from shadows helped to give the white water more of an impact. The

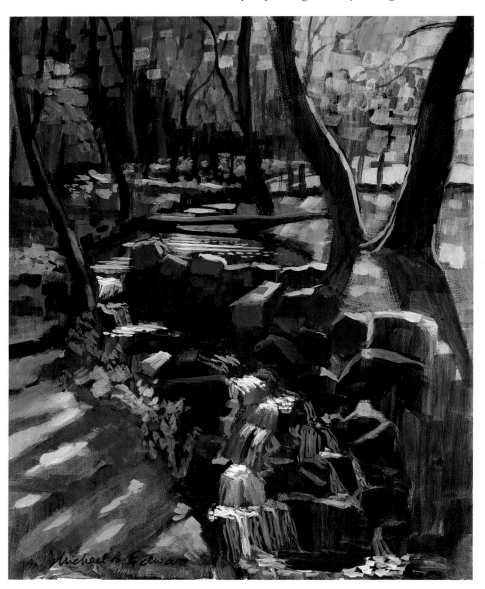

Woodland Waterfall
Acrylic, 20×16in
(51×41cm).
Waterfalls provide useful material for the painter. This small stream through the woods was of particular interest as the light filtering through the branches and leaves created patterns of sun and shadow to add variety and colour to the painting.

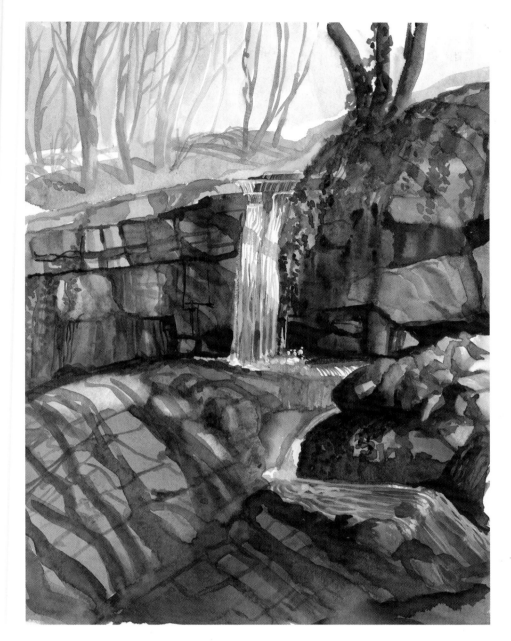

Waterfall in the Black Mountains

Watercolour, 20×16in (51×41cm).

Whereas the painting opposite focuses on the light and shade catching the water trickling over rocks, here the waterfall adds drama to the scene as it plunges over the side of the cliff. The composition emphasises the drama and contrasts the texture of the rocks and surrounding landscape with that of the falling water.

dark foreground also causes the eye to focus on the watefall itself. Perspective issues can arise with waterfalls such as the painting in the woods opposite. When falling over a number of rocks down a hillside, the size of the rocks, and generally depth of each stage of the waterfall will get smaller further away from the viewpoint. Similarly you will often be looking down on the water in the foreground whereas higher up the water may be level with your eye or even above eyelevel. The perspective diagram overleaf will clarify this further.

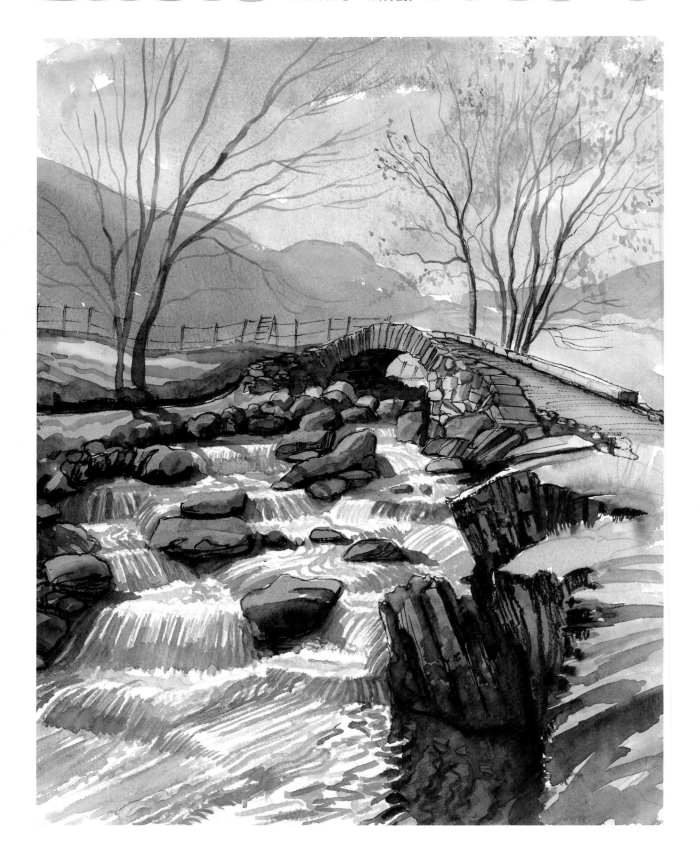

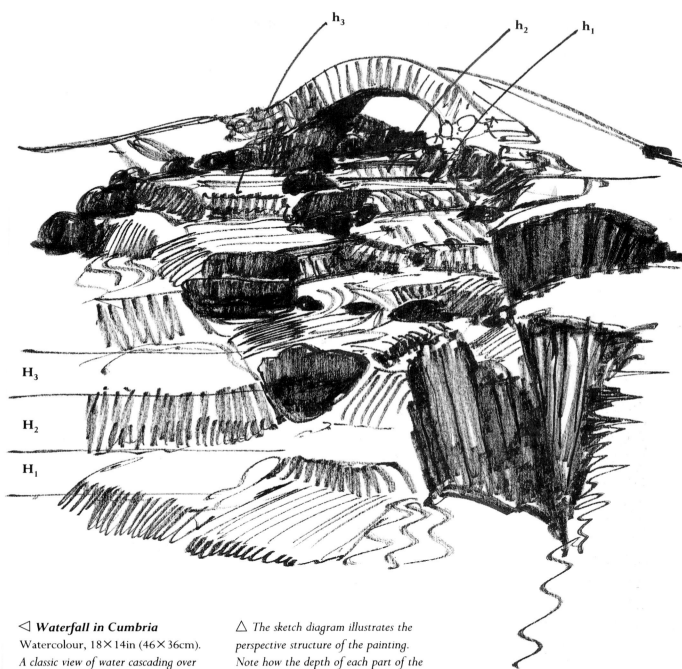

h_3 h_2 h_1

H_3

H_2

H_1

◁ **Waterfall in Cumbria**
Watercolour, 18×14in (46×36cm).
A classic view of water cascading over rocks with an old stone bridge in the background. One of the keys to this type of picture is the perspective created by the different levels of water as the river flows between and over the rocks.

△ *The sketch diagram illustrates the perspective structure of the painting. Note how the depth of each part of the waterfall in the distance close to the bridge (h_1, h_2, h_3) is much smaller than similar depths in the foreground (H_1, H_2, H_3). As the river descends so the viewer can see more of the horizontal* stretches between each waterfall.

The painting depends on a linear description of each waterfall element as in the diagram.

CITYSCAPES

Water in the cities adds an extra dimension to cityscapes. It can add light, movement and colour to brighten a rather severe or mechanical view of a city. Quite often rivers are at the heart of famous cities – the Seine in Paris or the Thames in London – and any set of paintings of those cities would be incomplete without a view of the famous riverside landscape. Composition problems can arise handling a wide river in a city. An attractive view of the city across a river will create a large empty foreground with a strong horizontal bank often cutting your picture in two. Unless the river is still enough to provide vertical reflections which help the eye to cross the open space, or you have tall masts of ships or bridges to lead the eye across, then it may be best to avoid the scene and find another viewpoint.

In the painting of *Buckingham Palace* from St James's Park, London, the banks of the lake lead the eye into the centre of the picture and the reflection helps to fill the space of the lake in the foreground. Note how the birds also add interest (and are a feature of the location).

In the Vancouver painting opposite, the water adds light to this bright summery picture with the distant towers of downtown Vancouver being reflected and adding verticals to offset the strong horizontal road.

The inevitable joggers provide interest and authenticity to the picture painted from Stanley Park, a large and attractive area of woodland and open space close to the centre of this beautiful Canadian city.

Finally, I have included a full cityscape painting: office blocks, churches, boats and even a disused lighthouse converted to a pub. The acrylic of Bristol uses the water to create the central feature of the picture with boats either side, between the converted warehouses and new office blocks. The spire of the ancient church adds a focal point with its reflection helping to fill the foreground water and contributing to the geometric composition. The water was painted with thin washes of colour over an underpainting of diluted Hooker's green. Bristol is fortunate in having its harbour, once filled with tall sailing ships, running through the middle of the city, making it a favourite place for cityscape painters – full of endless numbers of possible subjects.

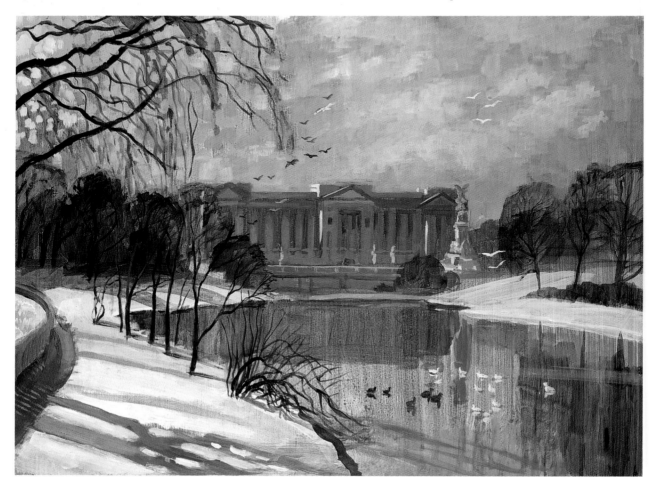

 Vancouver from Stanley Park
Watercolour, 12×16in
(30.5×41cm).
*Vancouver is a city
surrounded by water,
enabling paintings of the
city downtown to be based
on a waterside view, in this
case from Stanley Park.*

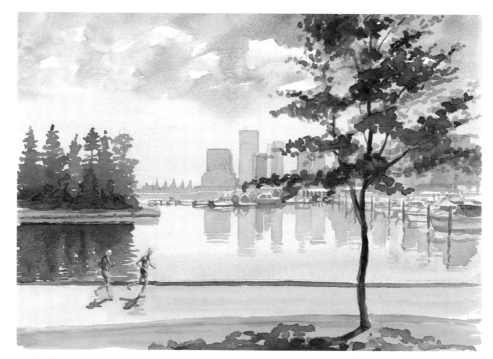

▷ **Welsh Back, Bristol**
Acrylic, 18×24in
(46×61cm).
*A classic cityscape with
offices, warehouses and
churches, and even a lightship
now used as a pub! Note
how the off-centre spire and
its reflection create a useful
focal point to this complicated
subject.*

◁ **Buckingham Palace,
London**
Acrylic, 18×24in
(46×61cm).
*Water adds light and interest
to city scenes such as this
famous view of Buckingham
Palace from St James's Park.
Painted over an
underpainting of neutral
grey (which forms the water
in the foreground), the
painting uses the subdued
tones of winter to add
atmosphere to this snow
scene.*

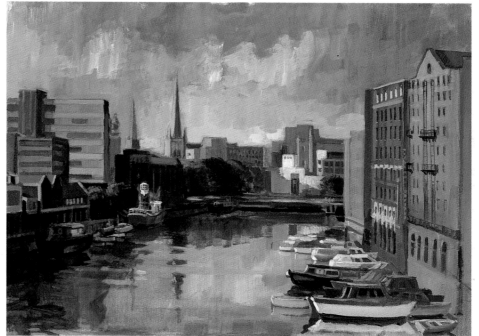

The ultimate location for waterscape painting is the city of Venice. Paintings abound of the liquid reflections of elegant Italian architecture in the Venetian light. It has been a magnet for painters for centuries and is a personal favourite for a painting visit. Over the centuries the very best artists have flocked to paint Venice, and it remains a wonderful, inspirational place for both professional and amateur artists.

5 Techniques and Style

Famous contemporary painters often develop styles which are instantly recognisable at a mixed exhibition. Style is established by a particular combination of medium used, subject selection, colour combinations, brush strokes, drawing method, degree of detail, method of underpainting, use of texture and probably many other elements. It will often reflect the artist's innate skills, and earlier experiences.

Often a beginner will wish to emulate the famous and perhaps with a book of examples, will produce some imitations. This can be a valuable exercise but should not be an end in itself. Ideally, having learned alternative methods and different approaches you should go on to develop your own distinctive style.

Clearly if you feel that your medium, style and results are exactly appropriate to your needs, carry on painting as you are. However, it is often true that a change of medium or technique will provide new insights which contribute to an improvement in the original approach. A spell at an oil painting course can help a watercolour painter and vice versa. This chapter briefly outlines various media, with some comments relating to waterside landscapes providing examples which illustrate differences in results and applications.

The painting, right, by Neil Murison, a versatile and experienced painter based in the West of England, illustrates a very fresh use of watercolour with a wonderful subject in the Caribbean island of Tobago. Neil's sweeping washes keep the painting lively and interesting with translucent colours picking up the atmosphere and ambience of the Caribbean. The palm trees on the right treated with loose brushwork instantly establish the location and provide an interesting contrast to the pale washes of sea and sand.

94

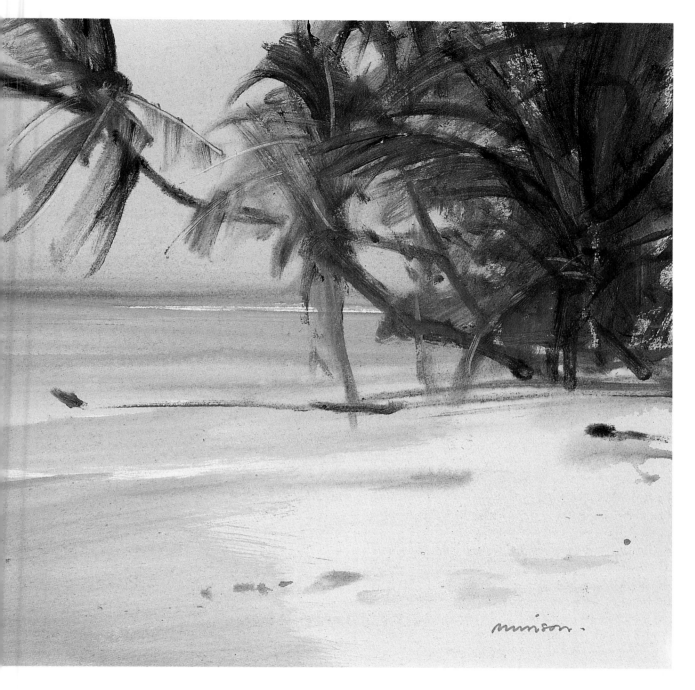

Beach Scene in Tobago, by
Neil Murison RWA
Watercolour, 16×20in (41×51cm).
*Painted by West Country artist, Neil
Murison, this watercolour captures with
an economy of wash and brush strokes
the atmosphere of a Caribbean beach in
the morning light. The vigorous
treatment of the palm trees contrasts
with the simple washes of sand and sea
to capture the essence of the subject.*

MEDIA ALTERNATIVES

Pencil

Used widely for preliminary drawings or sketches, the pencil drawing can be a delightful medium for a finished work. A wide range of effects can be achieved by different grades of pencil and paper, from the very soft grainy surface resulting from say, a soft 6B graphite to the precise lines of a hard HB or H. Also it is possible to obtain a vast range of coloured pencils or pencils which use another medium, such as oil pencils or watercolour pencils. Pastels have different characteristics and can be used to create paintings of immense complexity using a full range of techniques equivalent to the other colour media such as watercolours or oils.

When using pencil the quality of the line is important. Each artist has a different quality of line when drawing. Just as in handwriting there is a uniqueness arising from physiological and psychological influences. A line drawing by an experienced artist can be a joy to behold. Lines are drawn with an amazing economy and freshness which describe in a few strokes a total environment. Alternatively, pencil can be used to describe tones by shading, creating a three-dimensional picture. Various techniques help to keep line drawings fresh and clean.

The use of hatching for shading is one such technique illustrated here, the space between the lines differentiating lighter and darker tones. This type of hatching or cross-hatching creates a far better result than rubbing the pencil across the surface. Other drawing techniques which can be useful are illustrated for brickwork, or the stones of bridges and harbour walls, for seas and waves. The use of an eraser to create highlights can be valuable, particularly the use of the soft putty type. With a sketchbook the pencil can record for later reference notes of landscapes or detailed items to be used later in the development of a new picture.

The old masters, Rembrandt and Leonardo among others, produced exceptional drawings of individual elements of a proposed painting, including figures, houses and architecture. Similarly the cartoon, often full size, was frequently a very sophisticated drawing, showing the three-dimensional appearance of the final proposed painting. Drawings can be the basis of a watercolour painting whereby the completed pencil drawing has colours washed on to it. In this case the drawing needs to be firm enough to show through the paint. For someone with good draughting abilities or who is nervous about handling watercolour, the coloured drawing

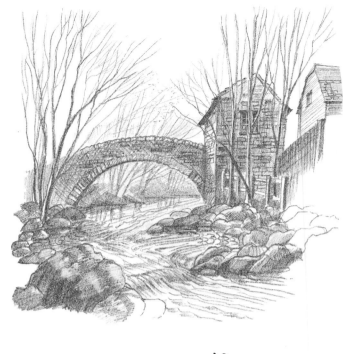

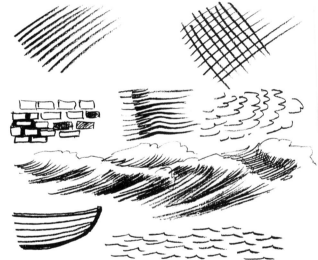

approach can be a useful method of developing painting skills.

A relaxed state of mind communicates instantly in drawings. The flowing lines, confident statements and lack of fussy detail all tell much of the artist's mental condition. Often in a class, students who have struggled with the drawing of a figure or still life will return from a coffee break and immediately correct or redraw with style and confidence. The same is true, but more so, in watercolour painting as described in the next pages.

Relaxation comes from self-confidence, perhaps the result of much practice or good teaching or both. Also the standards you set yourself are important. Never be satisfied if you feel your drawing or painting isn't good

enough. Try, try again. Look carefully at a particular drawing that you like and see if you can analyse the lines and how the artist has described the subject. Sometimes an experienced artist will leave the changes he has made to his line drawing which can tell you what he has rejected and why.

Pen

Much of what has been said about pencil applies to pen and indeed many technical aspects of drawing are similar. Pen, however, has other characteristics. The line can be more easily varied from thick to thin and the variations of thick and thin are very important to the quality of a pen drawing. Pen demands first-time results even if you are applying pen to a pencil outline; the mark you make with the ink is permanent. Confident handling is even more important. The thickness of the line varies in different ways. With an old-fashioned nib or even quill pen the pressure applied varies the width of the line. With a calligraphic pen the nib is wide and chisel shaped, and thus varies with the angle at which it is held. A fine sable pointed brush can produce similar thick and thin lines with a greater variation and fluidity than most pens. Some painters use a pointed stick dipped in watercolour to produce a drawing with a unique quality about it. The principal concern in this section is the pen.

Using waterproof ink it is possible to wash colour on to a pen drawing without disturbing the ink line. In the pen and wash sketch, right, I followed a traditional path of pencil drawing, inked in by pen, the pencil then erased and watercolour added. This enables the drawing to be corrected first, and the pen to be used with certainty on top of the pencil. You can simplify the pen drawing by not drawing in some of the pencil lines, producing a more relaxed economical style. It is also possible to use the pen drawing to create shadows through hatching and thus apply watercolours on top without having problems of achieving the correct tonal range. Pen is often used for detailed landscapes such as the pen and wash of Falmouth, and is useful for paintings of sailing ships and yachts.

It is sometimes possible to use pen in the foreground leaving background elements to be pure watercolour. This application can be seen in the painting of Ashness Bridge on pages 70–71. A similar approach of using a line drawing as part of the final picture can be used in oil painting, although the technique varies. Often the final oil paint covers some part of the original line, creating a sensitive and interesting effect.

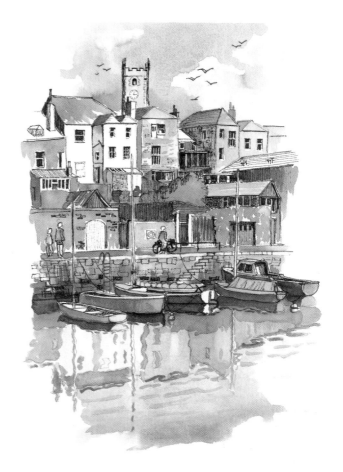

Falmouth Waterside
Pen and Wash, 16×12in
(41×30.5cm).
Pen and wash can create a light and lively work where the watercolour is used primarily to colour the picture. The original pencil drawing can be inked in with confidence, having solved problems of perspective and composition beforehand.

The certainty of the line, particularly with pen, can be combined with the looseness of watercolour to create a work of distinction and character as in the painting above, *Casting Off* by Patrick Collins. Patrick, who is an architect by training, has total control over the line drawing and a very good sense of structure and form as you would expect from an architect. However, his fluid, flowing lines and casual elegance are far removed from the exactitudes of an architect's drawings. Note how he does not use more line than is absolutely essential to describe a shape or form. You can also see some of the original pencil lines and how the pen has only picked up the minimum of lines leaving many pencil lines untouched. Finally, on top of the waterproof ink, a wet, almost monochromatic wash has been applied to represent the sky and background. The smoke has been painted into the wash while it was wet, and a lot of white paper has been left creating a fresh and spontaneous look.

Pure Watercolour

With many variations of technique applied to watercolours using pen, masking fluid and other manipula-

tions, the term pure watercolour has developed to apply to traditional brush-based watercolour paintings. Pure watercolour also differentiates the traditional paints from the newer water-soluble media such as acrylic. Pure watercolour depends on the washed colour and tonal variations for its effects and can be a most delicate, sensitive and atmospheric medium. Considerable skill is necessary to apply washes, some wet, others nearly dry, leaving the surface showing. So too is the ability to apply wet in wet, inclining the paper this way and that to make the merging colours create exactly the intended effect.

In my watercolour of Fowey harbour, right, pure watercolour seemed to be the best medium to achieve the softness of a grey late-summer day, the rain clouds passing overhead and the wet mud reflecting in the foreground. As you have seen, I am not one who is against all manipulations through masking fluid, pens, multiple washes or scratching, scraping and so forth; if such methods can achieve the result you want, so be it. The merit of the end result is not affected by the means. Usually the viewer will respond to the end result rather than to the means of achieving it.

◁ *Casting Off,* by
Patrick Collins, ARIBA
Pen and Wash, 10×14in
(25.4×36cm).
*This elegant work demonstrates the
subtlety which can be achieved with the
pen line. Note how the variation of thin
and thick line creates an interesting
variety to the drawing with watercolour
being added in loose washes to
complement the line.*

Fowey, Cornwall

Watercolour, 16×20in (41×57cm).
*This traditional watercolour uses
brushwork for its effects with no pen,
pencil or masking fluid. This type of
painting, sometimes called 'pure
watercolour', is based on the original
concepts of the English watercolourists of
the eighteenth and nineteenth centuries.*

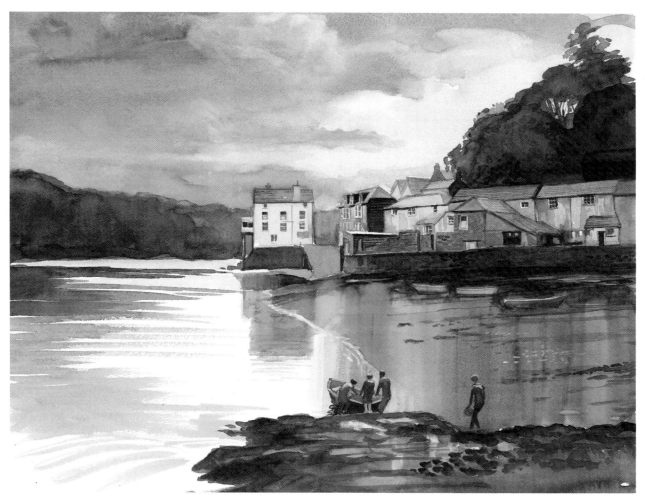

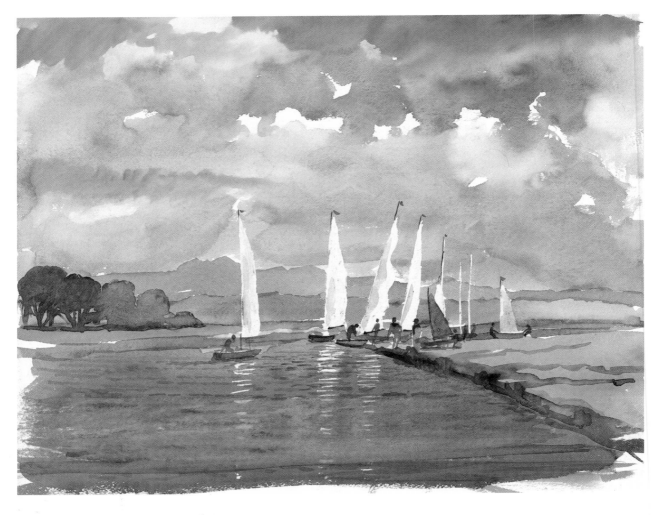

Loose Watercolour

Sometimes called watercolour impressionist painting, the loose watercolour describes a technique where the brushwork is very free with little preparatory drawing and where tone and colour are achieved with a single brush stroke. The result is a fresh, spontaneous painting which often has clean clear washes resulting from a single wet application with the brush. In my painting above of sailing dinghies on a river the clouds, background and sails are all painted with little detail and broad wet brush strokes. White paper shows between washes and in sky and sails and it has a spontaneity which came from the use of a large No20 brush, little preparatory drawing and fast wet painting.

Some painters specialise in this form, and two well-known contemporary painters in UK spring to mind – Ron Ranson and John Yardley – who work with great fluidity and freshness, using large brushes (Ron Ranson has marketed his large flat brush 'the Hake'). Often leaving more white paper than I have in the above painting

Before the Race
Watercolour, 16 × 20in (41 × 51cm).
A loosely painted watercolour, this
painting depends for its impact on fresh
washes painted with a large wet brush.
A loose 'impressionist' style of watercolour
is very popular currently in the UK and
North America.

they create an impression of light and colour with soft edges and little detail or fussiness. Neil Murison's painting at the beginning of this chapter on pages 91–92 is equally fresh and loose requiring great skill in handling wash and colours but creating a fine picture as a result.

Acrylics

Water-based paints, very different from watercolours, acrylics have properties similar to both oils and watercolours. Acrylic paints can be applied thinly as washes or

thickly, impasto style, in a similar way to oils. They are synthetic colours, hence very bright and consequently they have found favour with modern painters. Very quick drying, they can be painted on board, paper, canvas or virtually any oil-free support. While oil paints can be applied on top of acrylics the reverse does not apply. Because they dry so quickly it is difficult to work wet into wet and gradate tones or colours. It is also very difficult to avoid brushes being ruined by acrylic paints as the paint dries on the brush ferrules while you are working and the brush loses shape. Nevertheless, acrylics have considerable advantages and some individual painters use them extensively – others not at all.

For myself, I am pleased with the quick drying nature of acrylics and their strong colours and I have used them successfully for years. I also find they make an excellent underpainting medium for oils and a good sketching medium being both quick drying and soluble in water. The materials and equipment for use in acrylic painting are described earlier (see pages 18–19). Acrylics can be painted using a pen-and-wash technique as described for watercolours. The washes do not behave in exactly the same way as watercolours but nevertheless a very similar result is achievable.

In the painting top right, I have left the underpainting showing with vertical brush strokes of diluted Hooker's green being visible. The painting is on a smooth board, with a white acrylic priming. Subsequent painting of the picture, particularly the sky and sea, used loose, open brush strokes which let the green of the underpainting show through. Interesting colour combinations and apparent depth of the paint can be achieved in this way. The photographic process used to transfer the painting to print has over-emphasised the lines of the underpainting in this reproduction.

Another view of Venice, below, has the same basic formula: a white acrylic priming on a board, followed by a cobalt blue underpainting. In this painting the brush strokes of the underpainting were less visible, and the picture uses small blobs of colour in an impressionist manner, which with the quick-drying properties of acrylics and their strong hues, produces a lively colourful painting. I have tried to capture the late afternoon sun, across the lagoon with the foreground gondolas in shadow. The colours used were: cobalt blue and crimson for the sky, Hooker's green, cobalt blue and yellow ochre combinations for the water, Payne's grey and raw umber for boats and poles.

Top
The Grand Canal, Venice
Acrylic, 12 × 12in (30.5 × 30.5cm).
Acrylics can be painted thinly as watercolours or thickly as oils. In this example a thin underpainting is brushed strongly on to the priming and thicker brush strokes are used for sunlight, reflections and clouds.

Bottom
Venice, Evening on the Lagoon
Acrylic, 12 × 12in (30.5 × 30.5cm).
Using a similar technique to that for the Grand Canal above, this painting uses more opaque brushwork and demonstrates also the more intense colours of acrylics compared with those of watercolours or oils.

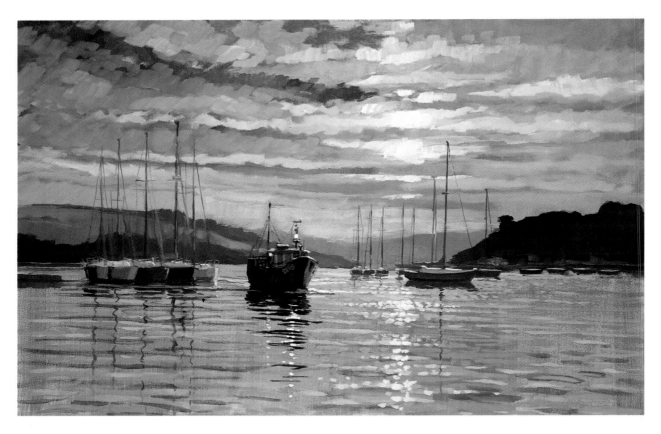

Oil Painting

The traditional medium over the centuries, oil paint is remarkably durable. With appropriate cleaning, an oil painting hundreds of years old can look as fresh today as when it was painted. More viscous and slower drying than acrylic, oil paints can be 'worked' on the canvas to create gradated tones of smooth paint or heavy impastos with the strokes of the brush remaining visible after the paint is totally dry. Care has to be taken when adding layers of paint that the underlying paint is thinner than the next layer otherwise cracking can result when the picture dries.

For painting on site, oils are less portable and less easy to handle than watercolours or acrylics. A combination box and easel set (as described in the Materials and Equipment section) helps to ease problems of carrying all the equipment necessary, but the slow drying of the oil paint will make it more difficult to carry the finished work. Nevertheless, to mould and shape the fluid paint on a canvas in front of an inspiring waterside landscape will continue to be the dream of many a committed painter in oils. The drying process can be speeded by the use of more turpentine or by using drying agents. New technology is also developing other paints which have drying times between those of acrylics and oils.

Dawn Departure from Salcombe
Oils, 24×36in (61×91.5cm).
Painted on to an acrylic underpainting, this oil has both thin and thick passages. More blending of colours is possible with oils than acrylics and the paint has a more viscous feel with a sheen to the surface of the dry paint, compared with the matt finish of acrylics.

My own preference is to use an acrylic underpainting – perhaps a monochrome interpretation of the scene and then to paint oils on top. Alternatively I will sometimes paint a full acrylic sketch on board or canvas and over-paint it in oils in the studio, using the different qualities of the oil paint to achieve different effects than can be achieved by acrylics alone. Remember that acrylics will not adhere to an oil-based surface.

The texture of canvases varies widely from a very rough weave to a fine, almost flat surface. This 'tooth' will dramatically affect the resulting painting. Often painters will use the tooth of the canvas to drag paint off the brush.

Acrylics and oils have similar properties when used for opaque and impasto effects. If you enjoy one it is

The Riverside Path, by Michael Long ACSD Gouache, 11½×11½in (29×42cm).
This tranquil landscape by Michael Long demonstrates well the properties of gouache. An opaque medium, the foreground reeds illustrate the method of painting individual leaves using the quick-drying properties of the paint. The support used is a pulp board which has a slightly rough surface, allowing the paint to be dragged across, with textures as seen in the cornfield.

worth trying the other to gauge the differences and whether you prefer the attributes of either. Or you can use them both together.

Gouache

Other media can be used to great effect in waterside landscapes. The example shown above is in gouache by Michael Long who has used the medium for many years. Opaque and water based, the quick-drying paint can produce a range of effects similar to those of oils or acrylics. Also known as body colour, it is made from less finely ground pigment than that used for transparent watercolour. The medium is extended with white pigment which makes it opaque, and thus less luminous than pure watercolour. Very useful for detailed subjects, as you can add light colours over dark, the medium is used extensively for commercial reproduction and there are commercial ranges of gouache paints called 'Designer's Gouache'. The opacity of gouache and its ease of handling create excellent paintings for reproduction. However, beware of some gouache paints, particularly when produced for the commercial market, as these do not have the durability or permanence required for a long-lasting fine art painting. Gouache uses the same brushes and papers as watercolour, but can also be applied to dark-toned papers or boards. While painting with gouache has some similarity to oils, it has a character entirely of its own and the end result is unique. As with other media, practice leads to skill.

Gouache is often used to touch up a watercolour painting and the term 'body colour' is usually applied to this role. Its opaque quality means that details can be applied on top of a watercolour, where otherwise great difficulty would be encountered to achieve the same effect. In waterside landscapes you will often find gouache white helpful to paint in yacht masts, rigging, windows or reflections of ripples in the water.

Pastels

Another medium used extensively to paint waterside landscapes is pastel. Without the problems of drying speed or mixing on the palette pastels can be applied with great vigour and freshness, using the tooth and tone of the support to create different textures and effects. Colours can be varied by multiple applications but as in pencil drawing, the techniques for maintaining a freshness and to avoid dirty mixes of colour need to be developed. Extensively used by Impressionist painters such as Degas and Toulouse-Lautrec, the beauty of a fine pastel painting is equal to any other medium.

Media can be mixed. Frequently pen, watercolour, gouache and pastel will appear in the same painting and interesting results can be obtained. It's very much a matter of temperament, whether exploring alternative media or mixed media appeals. For many years I felt that watercolour had enough variety and challenge to keep me fully occupied but I have enjoyed my involvement with acrylics and oils and now am happy to use all three, with the occasional venture into gouache, pastel or others.

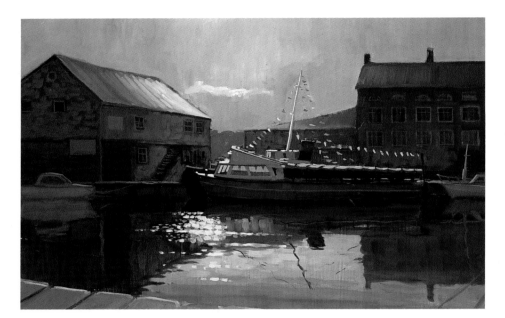

Awaiting the Summer
Oil, 16×24in (41×61cm).
*The attraction of this subject
was the light on the pleasure
steamer, still with its bunting
in place, although out of
season. Selecting a subject is
very much influenced by the
artist's eye — or a particular
interest the artist may have
at the time.*

SUBJECT SELECTION

When you march into the country heading for the waterside location what are you going to paint? What subject will you choose, how much and how little of it will you put on your paper? Why are you painting it? Do you want to develop further some style or technique of painting or are you setting out to depict a place, perhaps a holiday spot, which will remind you of a visit, an emotional reaction perhaps or nostalgia for that particular scene. Perhaps it's a nice sunny day and there is nothing better to do than to sit by the waterside and paint — it's the act rather than the subject which is important. It is useful to understand why you are painting in the first place, and what it is about the subject you choose which fulfils your initial objective.

Having chosen your subject, for example the corner of the harbour, with its colourful pleasure boat moored waiting for next season to commence, and the sun glinting on the water, ask yourself how much or how little should you include. Now it is compositional elements which predominate and the criteria for selecting what to include should take into account some of the alternatives identified in Chapter 3, page 49. One often-advocated way to assist is a card with a hole cut in measuring approximately 4x3in. Through this you can look at the landscape with the cut-out either vertical or horizontal and discern the way the scene might appear on your paper.

It is too easy to select the traditional landscape with the river winding into the distance through soft green fields and trees or the lake with mountains around it. Try

something different for a change, an unusual view such as the houses winding up the cliff path out of the Cornish fishing village, opposite, rather than the well-known view of the village itself. Or a different subject altogether as in the flooded fields shown below. Try a long, narrow format as in the view of Tenby, right.

How much should you use artistic licence to fit the scene before you into your viewfinder or to create a more appropriate composition? If you move the tree on the right to the left of the picture will it improve the composition? The large boat in the foreground perhaps should be in the background. I find that small modifications work well — leaving out the odd boat or two adding a flag here and there, or reducing the size of the jetty — but too much change and trouble could follow. Firstly you will lose the identity of the location and maybe something indefinable that made it attractive in the first place. Secondly, until you have committed yourself, the effect of artistic licence will not be fully understood. For small modifications the impact is less severe than large ones.

The subject out of doors changes continually as the sun moves, boats move, the tide comes in and out and perhaps the rain starts to fall. Painters outdoors develop a degree of anticipation. When the sun moves anticipate that the shadows will do this or that, which will improve or detract. Therefore, leave this bit till later or quickly catch it as it is. The tide is going out, thus before the picture is half finished, the boats will be in the mud, therefore come back earlier tomorrow . . . the forecast is rain, there's a big black cloud heading this way so take a photograph, do a sketch and paint the picture later.

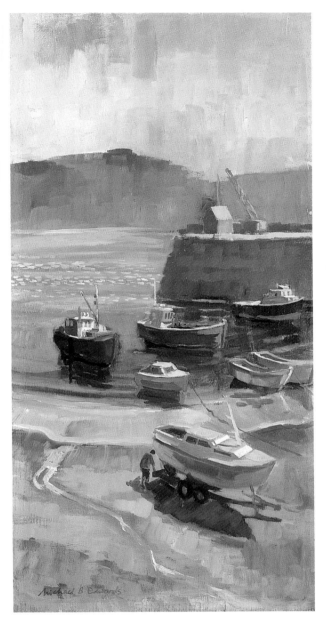

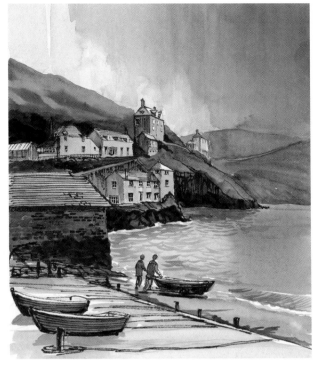

Top Left
Tenby
Acrylic, 24×12in
(61×30.5cm).
An unusual shape to the picture can often prove to be an attractive alternative to using standard sizes. It also makes you think about composition and design, sometimes with interesting results.

Top Right
Port Isaac, Cornwall
Watercolour, 16×12in
(41×30.5cm).
An unusual view can provide a challenge and interest. In this painting the steep hillside with an approaching storm makes a different type of composition from the more usual view of the harbour front.

Bottom
Flooded Fields
Acrylic, 20×16in (51×41cm).
Keep a look out for new ideas for paintings – passing this flooded field in Oxfordshire, I realised it would produce a different waterside landscape.

LIGHT

When walking round an exhibition check which pictures catch your eye. Is it the better drawn, the colourful, the unique subject – or does your eye fasten upon the painting with light sparkling in it? Is it the dazzling reflected sunlight on the harbour, the setting sun shining through the bare branches of the winter's evening or the hot, baking sunlit scene of a Mediterranean midsummer's day? The attraction of light to the artist was most dramatically demonstrated by the Impressionist painters who educated their public to see pure light and colour as legitimate subjects for the painter. Using separate brush strokes, sometimes separating the elements of colour, the Impressionists created a whole new concept of defining light in a painting.

The waterside landscape usually has light as a central theme, the water reflecting light from sun or sky. Either the sparkles from each ripple or wave will create an abstract pattern of light and shade or the water will create a mirror for the reflection of all the light in the landscape. Often the most dramatic effects can be found when the sun is low in the sky in autumn or spring or in the evening. Long shadows create variations of light and shade which can give a picture wonderful variations of tone and colour.

When you select your subject look how the light helps or hinders. Does it make objects stand out by creating shadows and three-dimensional forms or does it flatten everything? Unfortunately the untrained eye will be attracted by a sunlit scene in mid-summer which when painted faithfully, produces a flat result not at all as the eye suggested. So train yourself to look for shadows to create the illusion of depth and reality.

Light is continually varying either slowly as the sun moves or rapidly as clouds pass across. The variation by the time of day needs anticipation – look at a subject not just as it is but as it will be when the sun has moved. Sometimes you can tell clearly that with shadows in a different direction the whole harbour view in front of you will become very much more attractive in colour and tone, and you can time your starting to meet the best possible lighting conditions.

Clouds can have both a positive and negative effect. Positive in providing variations of light and shade across

the landscape making a much more attractive subject, or negative in changing the light at a critical point, just when you are working your way through a crowded boat-filled marina.

Quite often in variable weather conditions you know that there is a high chance of total change, hence you have to quickly sketch the scene with shadows in place and perhaps take a photograph as well. Then when it starts to rain halfway through the painting at least you can finish the picture in the studio. Alternatively by working through the most critical area, say harbour cottages or boats, you can set the tonal range and colour parameters, which you can then use later as a yardstick for the other parts of the painting. It is sometimes useful to paint quickly in acrylic a full size picture which can be developed in detail later in oils. Or use a pen and wash technique to make a lively sketch of the subject to be developed as a full-scale painting in the studio.

Study shadows carefully and experiment with colour and tone. You will see that shadows sometimes have hard edges and sometimes soft ones depending on the source of light and the distance of the object from the shadow. A flagstaff will cast a sharp shadow close to its foot which becomes blurred further away. The colour in shadows can be simply a darker version of the local colour of an object or ground, but most shadows contain some blue reflected from the sky – or occur in the distance through aerial perspective. Shadows can contain a complementary colour to the object casting the shadow.

Shadows can be created using spots of colour or alternatively several layers of watercolour of different colours can be washed, creating a luminous effect. In marine subjects reflected light will often be apparent; in such cases light appears in the shadow, reflected from a source other than the sun. For instance where two boats are moored alongside each other, the shadow of one may well contain reflected light from the other boat, which is in full sunshine. Look hard to find reflected light as it helps to give solidity and form to the object you are painting. Rocks in a river often exhibit reflected light, as do closely packed houses on the harbour front. Even in the evening scene opposite there is some reflected light on the nearest boat identifying the white topsides which would be otherwise in deep shadow.

Sunset on the Yealm
Acrylic, 12×12in (30.5×30.5cm).
*Painting into the light can provide
contrasts of tone with sparkles of light
reflecting on the water. The
underpainting of raw umber and raw
sienna shows through in the final picture
in both sea and sky.*

By the Bridge
Oil, 16×20in (41×51cm).
Painting into the light creates interesting effects of shadows and silhouettes. Accurate handling of tones is essential in this type of view.

Venice
Acrylic, 12×18in (30.5×20cm).
More dramatic cloud effects are achieved by painting into the light, and water can be suggested simply by using highlights for ripples and waves.

Painting into Light

For heightened contrast and dramatic effect painting into the light can add zest to your painting. You will find that strong tonal contrasts and interesting silhouettes will emerge often with a light 'halo' around them. Shadows will be cast towards you and water will reflect very brightly. In the oil painting above, the light coming through the trees creates a pattern of shadow in the foreground with the two figures being silhouetted at the water's edge. The very bright pure white reflection of the river adds a sparkle of light.

In the acrylic of Venice right, the lightning effect of the clouds, with the sun directly above, creates interesting patterns and enables the shapes to be sharply delineated, while the buildings are in silhouette and the water has simply stated highlights, where the sun catches the ripples on the lagoon.

The dramatic winter coastal watercolour opposite features a dark stormy sky with simply stated headland and jetty. The streaks of light on the beach suggest a receding tide, with sunlight on the waves providing a highlight in the middle distance. The dark figure against the light adds focus and interest. For drama and lighting effects this type of painting has little to equal it.

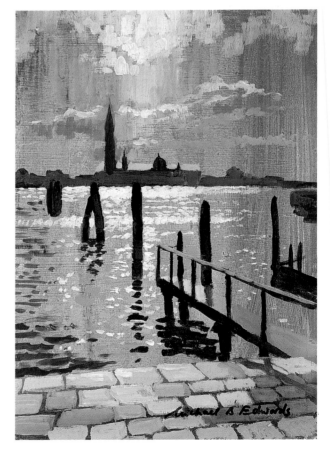

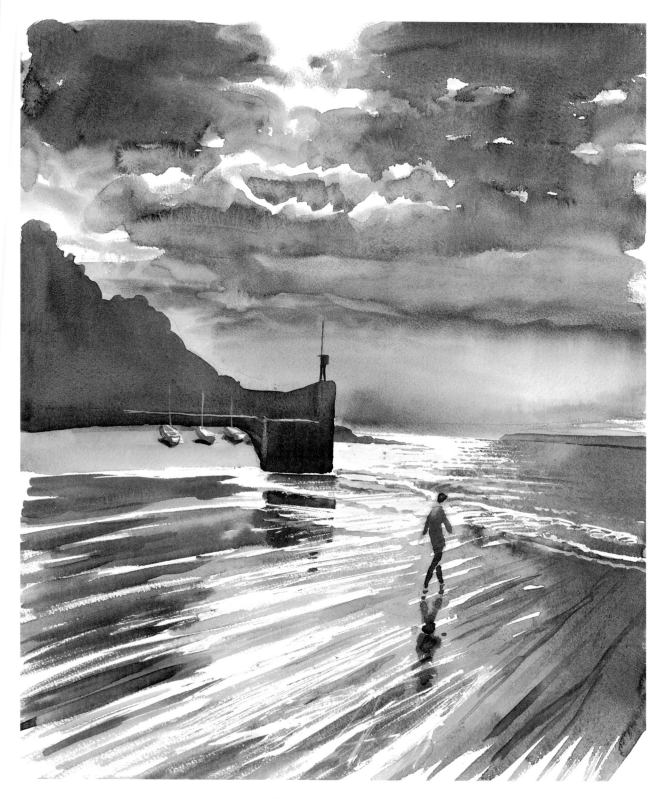

The Approaching Storm
Watercolour, 20×60in (51×42cm).
*For a dramatic atmosphere, the sun shining through dark clouds provides a theatrical
scene with the figure being spotlighted on the beach. Reflections in the water and on
the beach add interesting variations of light and shade.*

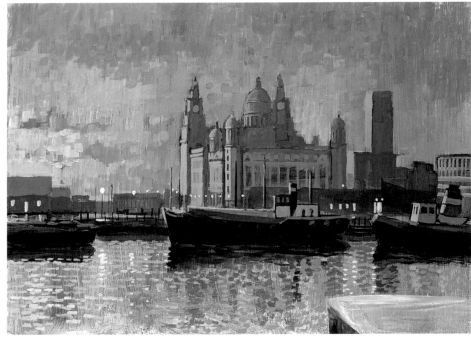

△ *International*
Convention Centre by
Night
Acrylic, 18×24in
(46×61cm).
The wet piazza in front of
Birmingham's Convention
Centre provides reflections
similar to those in a waterside
landscape. Night-time scenes
can be attractive subjects but
require either a special
vantage point or a camera
and tripod to capture the
essential elements of the
subject.

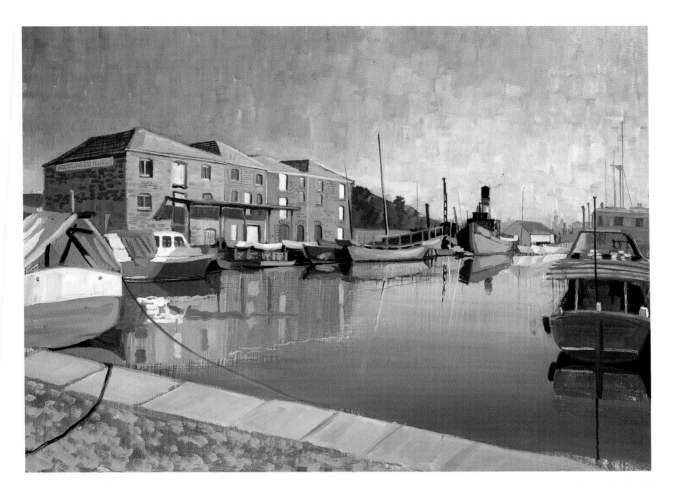

Other interesting lighting conditions include flood-lights in cities and harbours. The illustration, while not a waterside painting, uses reflections from a wet piazza to provide a dramatic night-time view of the International Convention Centre in Birmingham at Christmas. Night-time scenes have a special magic about them but you will need to use a camera and tripod to record the details.

The late evening when lights are just coming on can be a magical time and one it is possible to catch without resorting to photographs. Tonal control is essential, and a preliminary underpainting of a middle tone is often in-valuable to set a proper tonal base.

◁ **Liverpool Pier Head**
Acrylic, 18×24in (46×61cm).
The late evening has its own special magic, particularly when viewing a famous city waterfront such as in Liverpool. The tonal background to this painting was set by the grey underpainting.

△ **Exeter Maritime Museum**
Acrylic, 18×24in (46×61cm).
Note in this picture how the tones between sky and buildings and boats varies along the horizon. The sky is darker in one section, the boats darker another. This variation of light and dark tones on a boundary is termed 'counterchange'.

Counterchange is a term frequently used to describe the use of dark and light tones set alternately to create variation and interest in a painting. For example, in the painting of Exeter Maritime Museum, above, notice how the sky at the horizon varies from dark at the left to light at the right, while the tone of the buildings on the left is light and the ships to the right are dark. You will find this variation in most paintings, often cunningly used by the experienced painter to add interest and variety to the light in this picture. The same counterchange effects can be seen in the painting of Liverpool waterfront, where the buildings have light against dark and vice versa.

COLOUR

The waterside can be a place full of colour and gaiety with flags and bunting fluttering in the breeze, brightly coloured fishing boats and sails – or on the beach all the colours of sunshades, windbreaks, summer dresses, kites and windsurfers. In the watercolour right painted in Concarneau, France, the local Breton fishermen appear to compete with each other to create the brightest colours for their boats.

Colour can add warmth to a painting or equally it can make it feel cool. It can aid the composition by creating focus and interest at key points, it can be vibrant or it can be dull. We have seen how colour can provide aerial perspective to make the distance recede and the foreground protrude. Colour can add cohesion or discord. It is an important element in the creation of an effective painting.

Warm colours are often associated with reds and cools with blues. Also the location of colours in a painting can affect the colours themselves as there is considerable interaction between them. An underpainting of a warm or cool colour will permeate the picture with warmth or coolness. A preliminary all-over wash can provide a particular ambience to the final result. In addition, the appearance of the underlying colour in various places across the total picture can provide a cohesion to the whole, and produce a quality feel to the painting. Sometimes painters will deliberately add spots of a similar colour throughout a painting to create cohesion.

An overall coolness will help to create atmosphere of evening or winter. A sunlit winter scene will differ from a sunlit summer scene not only by the shadows but by the warmth and intensity of the colours. If you paint the landscape as you see it, the results will often incorporate the warm or cool colours of the season, but you can accentuate or diminish the effects by deliberate use of colour. Likewise, where something looks odd in a finished painting it may be the wrong warmth or coolness to a particular passage.

You will develop an understanding of the warm and cool colours in your palette through experience and by comparing the effect on paper of different colours or mixes. Complementary colours add vibrancy. A complementary colour is its opposite on a colour circle, for instance, the complementary of blue is the mix of red and yellow. Likewise for red it is green and for yellow it is mauve/purple. Placing complementary colours next to each other creates a strong reaction in the eye. In the

picture of the Concarneau fishing boats the red and green boat in the foreground demonstrates complementary colours as do the blue and orange of the next boat. While these colours were decided by chance by the Breton fisherman there is often scope for you deliberately to introduce complementary colours.

Fishing Boats, Concarneau, France
Watercolour, 14×18in (36×46cm).
*The Breton fishermen appear to compete
in making colourful fishing boats. The
use of complementary reds and greens
makes the colours particularly vibrant.*

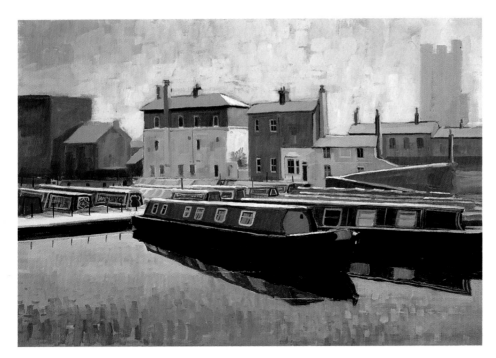

Gas Street Canal, Birmingham
Acrylic, 18×24in (46×61cm).
The use of a strong colour as a focal point has been the practice of artists for centuries. The bright red end to the coach roof of the barge in this picture provides a classic use of colour to create focus.

Colour can attract the eye and create focus. A man overboard at sea in a bright orange anorak is instantly seen, whereas one in blue or green would not be. In the above painting of canal boats the bright red of the foreground boat attracts the eye and creates instant focus for the picture. Often where the obvious focus is missing in a scene it is possible to add a figure in bright colours to create just the focal point you lack. It is easy to see how the old masters used this in crowded battle scenes or religious paintings where a spot of colour can focus the eye on to the key characters in the painting. Equally, a bright colour may distract the eye if painted faithfully into your picture. You have to be selective and reduce the intensity of distracting colours.

Colour and tone can often be confused. Tone relates to how dark or light one area of a picture is compared with another. A black-and-white photograph is an example of a purely tonal picture; it accurately represents the subject but has no colour whatsoever. Photographers often use black and white when they want to avoid the distraction of colour and concentrate on tonal or textural variations, light and shadow.

Before colour photographs were invented, one sometimes saw coloured photographs where tints had been applied to a black and white print. So in painting the same process can be pursued where a monochrome preliminary painting is used, subsequently coloured by a top coat with the tonal variations following the monochrome underpainting. In this way the painter can sort out the tonal structure without the complications of colour and then consider colour without the problems of tone. When considering pen and wash we have seen how it is possible to shade a pen drawing using hatching and cross-hatching, subsequently adding colour washes. Sometimes in museums you will see a seventeenth- or eighteenth-century unfinished painting where a monochrome underpainting is clearly visible.

With watercolour one approach is to paint shadows of various tones first, building subsequent colours and light tones later, a technique which has similarities to the monochromatic approach. However, the loose style of watercolour impressionists depends on washes of precisely correct colour and tone applied with a sweep of the brush – hence one of the difficulties in what looks to the uninitiated perhaps as a simplistic approach. Likewise the impressionists would apply dabs of oil colour, impasto style, of exactly the right colour and tone, directly on to a white or natural-colour canvas.

The range of tones in a painting will vary. A high key painting will have few dark tones, whereas a low key painting will have mainly dark tones. The key of the painting, whether high or low, will affect the mood or ambience portrayed. In the examples on the opposite page the high key of the Windermere watercolour gives it a soft quietness relating to the still winter's day in the English Lakes, compared with the dark contrasts of the lower key painting of Brixham in Devon, looking into the light on a bright afternoon, with a sharp light silhouetting the skyline and swirling clouds suggesting possible rain to come.

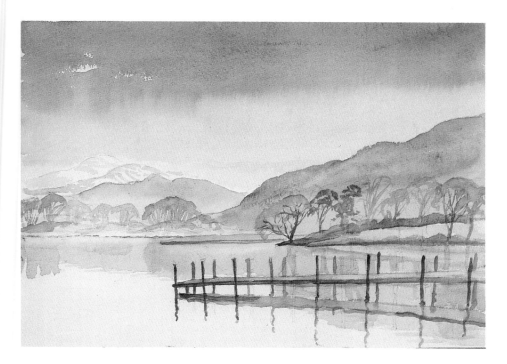

Windermere, Winter
Watercolour, 10×12in
(25.4×30.5cm).
The pale tones of this quiet winter's scene create a high key picture, with few darks to be seen.

In my experience less confident painters will rarely use the full tonal range in their paintings and thus produce a rather insipid result. A useful exercise is to use black ink for the darkest tone and structure your tonal range from white unpainted paper to the black ink.

Another critical aspect of tonal control is its use in aerial perspective. From the rear of the landscape to the foreground, tones have to be gradated to give a uniform sense of recession. In the distance tones (and colours) will be fainter than in the foreground. Tones of similar objects (say two boats) of equal distance from the viewer with similar lighting conditions will display broadly similar tonal values. The eye will often adjust to compensate for aerial perspective so that something in the distance, say a black building or boat, will look darker in tone than it actually is, your eye and brain telling you it's black, when for the purposes of your painting it's grey.

The use of toned papers can provide a valuable mid-range tone to avoid too high a key to your painting. Obviously the highest tone with watercolour is the paper – consequently to achieve a wider range on toned papers it may be necessary to use gouache body colour to obtain the lighter tones with the opaque paint.

▽ **Brixham**
Watercolour, 20×16in
(51×41cm).
The dark threatening clouds and dark tones in the town itself contribute to an altogether low key painting.

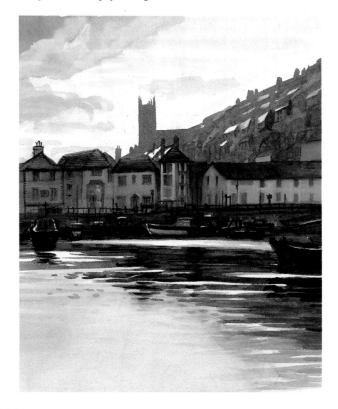

115

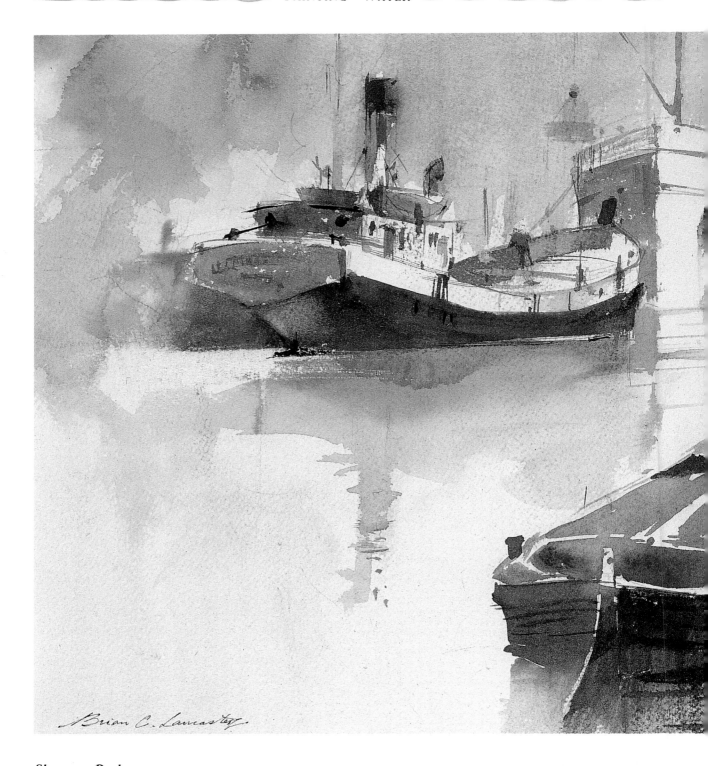

Sharpness Docks
by Brian Lancaster
Watercolour, 12×16in (30.5×41cm).
*The sweeping washes and delicate tones
of this beautiful watercolour have a style
and quality which is distinctly Brian
Lancaster's. Every experienced artist
develops a style which is unique.*

STYLE

Some paintings have great style or flair, such as the watercolour by Brian Lancaster, left. He uses sensitive washes, an economy of statement, great atmosphere and light, and has a style of his own. Every painter has his own uniqueness, through the interaction of eye, hand and brain, and the selection of media, subject and technique. Famous painters are often known for their famous style, usually backed up by exceptional quality and skill. They also often choose a certain type of subject and single medium for their major works.

It may seem to the beginner that it will be a long time before questions of style become relevant. But there is a strong underlying principle for all painters – namely the search for an individual way to express yourself in paint. How you like to do it using your particular talents is what matters. Clearly you can learn from the experts. You can study the latest exhibitions and magazine articles and try to paint using similar techniques and approaches but you should incorporate those lessons into your own way of doing things. You may decide that you will do things differently all the time – trying different styles according to your subject, or your mood, which is fine.

In addition technique helps you to explore options in finding how to paint the way you want to. So to be in command of your wash, for example, controlling its development and final appearance, gives you the option to paint it in many different ways.

The choice of media can help you to distinguish one painter from another. Sometimes a painter will develop a unique combination of media, with a distinct type of support which by itself will typify the painter's work. For developing a reputation and creating a marketable commodity, a successful painter will be one who creates a recognisable style which is consistently applied over an extended period. Some painters, through the pressure of galleries or marketplace, become stuck in a rut of producing similar work for many years – it's one of the problems of success.

ATMOSPHERE

Waterside landscapes usually have great atmosphere, for example the still coldness of a winter's day by the river, with frosty skeletons of trees and bushes reflecting in the dark depths of the water or the dappled evening sky of an autumn afternoon, with the ghostly shapes of the moored boats picked out by the dying rays of the sun. Such moving sights occur again and again at the water's edge, hence the great attraction of waterside landscapes.

For the painter to capture the essence of the water-side scene, it is essential to target the atmosphere as a principal objective in your painting. Using to the full elements of colour, tone, light composition and technique you should try for the interpretation close to your feelings as you study the view. Your paintings will stand out when they say much about atmosphere and character rather than a statement of fact about the location.

In my acrylic painting of the marina evening below the blue/grey underpainting and blue key to the painting as a whole was my reaction to the misty light pervading the harbour on that day. The watery reflections add to the mood and the light in the sky touches on the assembled boats and the background sheds to suggest their presence without needing lots of detail. The strong horizontals are offset by the spiky verticals of masts and reflections.

The watercolours opposite both depend for much of their effects on the underlying washes. In the sunset over Poole harbour, top, the red sky and reflected light in the water provide an overall dramatic atmosphere. Note how the blue shading of the clouds provides a complementary colour to the orange/red of the sunset. The impression of later evening is heightened by the low key and dark silhouetted shape of the pleasure steamer providing evening cruises around the harbour.

The Avon in winter painting below is based on a blue-grey wash of sky and water handled exactly as outlined in the stage-by-stage painting on pages 24–5. The lack of colour adds to the cold atmosphere which is heightened by the frosty twigs of trees and foreground grasses, using body colour to provide the whiteness. In all cases I have exaggerated aspects of the scene to convey the mood and atmosphere of the situation. Colour plays an important part in setting temperature and mood.

Beware of any idea of converting your summertime painting into a winter one by adding snow or trying to make a winter scene into a summer one by adding leaves to the trees. As we have seen, colour, light and tones all contribute to the atmosphere rather than any one particular feature such as snow.

Try painting on days you might normally avoid – overcast, raining or whatever. There can be a special magic in a painting of a wet day with rain glistening on rooftops, umbrellas bent before the wind and the blurred greyness of falling rain making hillsides merge into the clouds. Particularly in watercolour it is possible to capture some very atmospheric feelings in these conditions.

The character of a location needs to add more than

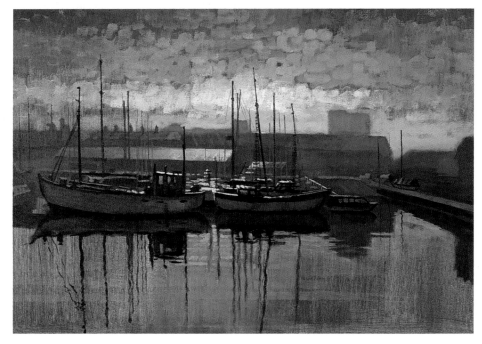

Marina Evening
Acrylic, 20×24in (51×61cm).
The overriding blueness of this painting, through the underpainting and subsequent brushwork, provides a cool winter's evening feel. This complements the low angle of the light and the evening sky.

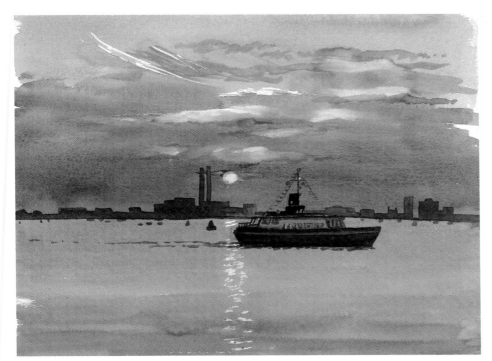

Poole Harbour, Sunset
Watercolour, 12×16in
(30.5×41cm).
Sailing into Poole one evening we saw this unforgettable sight of sky and sea in deepest orange, aglow with the sunset. The pleasure boat and buoys were silhouetted and the ambience of the evening was quite different from that of the daytime.

▷ **River Avon, Winter**
Watercolour, 12×16in
(30.5×41cm).
The cold stillness of a frosty morning creates an almost monochromatic scene, with not a ripple on the water. Search out atmospheric subjects and emphasise atmospheric effects to create more interesting pictures.

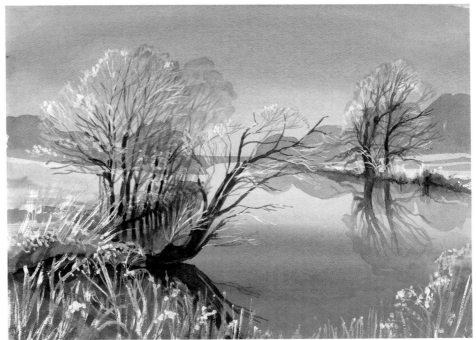

atmosphere. Certain ports and harbours have unique individual characters which need to be identified and captured. An Italian lakeside is quite different from and English or Canadian lakeside, for instance, and as we have seen previously, the Rockies are different from the Alps.

Try to put into your painting touches of character – the Breton fisherman perhaps or Canadian redwood fir-trees. Fishing boats differ a lot as do rowing boats and lakeside houses. So try to get your painting to say, 'Here I am on the east coast, on a breezy March day (and I'm feeling great!').

6
Sketchbooks and References

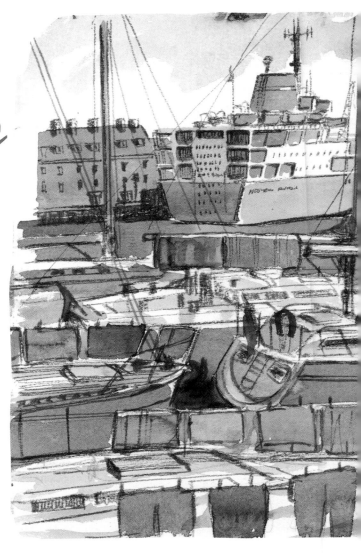

SKETCHING

You will hear so many times that the sketchbook is the painter's essential companion and it is worth repeating. The sketchbook should go with you always in the car, office or on holiday. Tucked in a pocket with pen or pencil it makes the perfect kit to practise, record, and enjoy the scene in front of you. Individual notes of boats or

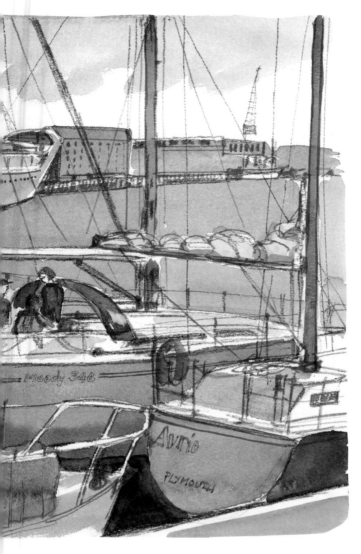

houses, or total landscapes can be drawn. Sitting in a restaurant your fellow diners can be the subject or on the harbour front the seagulls wheeling overhead can feature.

It is valuable to try out a painting site to see if the composition looks as good as you thought, or combined with a small watercolour box a quick colour sketch can evolve for future reference. Quietly sitting in a fishing port, noting how fishermen mend their nets or unload baskets of fish can provide valuable reference material, as can a quiet day by the river watching the salmon fisher cast his line.

A personal favourite is a calligraphic pen, but any sort of pen, or ballpoint will do. Plain cartridge paper is best as your line on the paper will be clearer and easier to make than on watercolour paper. Several of the sketches shown in this section were made on rough watercolour paper with the result that the lines look somewhat serrated. I often use watercolour paper as I will sometimes have my paints with me which results in the type of sketch shown opposite, *Weymouth Harbour*, where brush strokes of colour were applied without preliminary drawing, the details being added by using a marker pen afterwards. To save money it is possible to buy large sheets of paper and cut them up into smaller sizes, but for convenience I use the spiral-bound type of book which enables me to carry it in my pocket without damaging the paper.

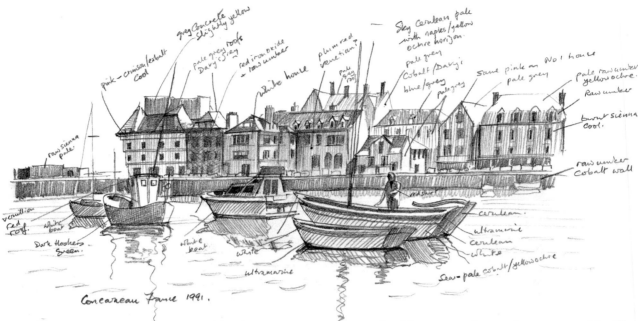

Concarneau France 1991.

When it is necessary to use the sketchbook to prepare for a final painting in the studio, you can add notes on the sketch indicating the colours necessary (as in the sketch above). This requires a reasonable knowledge of the colours in your palette – it also requires that the sketch is detailed enough to provide the information necessary for the painting, with tones and shadows identified. I rarely use this method myself as I find the watercolour sketch shown on the previous page is almost as quick and captures colours immediately on the spot. An alternative used by Neil Murison, whose painting of Tobago appeared on page 91, is to complete small watercolour sketches to capture the key composition, colour and tone parameters using this information back in the studio to develop final paintings.

USE OF THE CAMERA

The camera has a mixed reception among artists for creating reference material. It is invaluable to show up the details involved in architecture or when it is impossible to complete a picture in one sitting. In other situations it can be used to record a scene in case a rapid change in the weather causes a cancellation of the painting session without any hope of finishing the painting. In poor lighting – directly into the sun or at night or late evening – the camera can produce a very unusual, somewhat distorted result which has qualities with potential for a painting. In this case it acts as a thought starter for experimental work.

You should paint outdoors whenever possible. The result will be fresher and more original than when painting from photographs. As I normally take a photo of most landscapes before painting them (in case of serious interruption) I can compare the two results. I would obtain different results if I painted from the photograph. I find it easier to draw *in situ* – choosing where the boundaries of the picture will be rather than having boundaries imposed by the photo.

The colours in photographs are subject to the methods used by the processing laboratory and can deviate quite markedly from reality. Most compact, lower priced cameras, although fully automatic and thus supposedly ideal for taking notes for the travelling painter, have a big problem. They use a 35mm lens which is, in effect, a wide angle. It thus gets more into the print than you would expect but in doing so distorts the perspective, throwing your subject often far into the distance – useful if you want to capture the Parthenon from 20 yards but otherwise a problem.

Other reference material can be searched out from magazines and newspapers to establish a reference library of items such as animals, birds, ships, fishing boats and people. Particularly if you are intending to develop your work towards a professional or commercial career such reference material can be extremely helpful. When using photographs not of your own origin, be careful not to infringe copyright. A fully indexed library of references, your sketches, photographs and extracted material can be a valuable asset for the future.

A camera can be a valuable reference tool but beware of relying on it too much — it will cramp your style and prove inflexible in use. One problem is shown here: the wide angle lens commonly used in most automatic compacts throws the subject into the distance (see above). However, most automatics have the advantage of taking difficult lighting in their stride such as a photo taken directly towards the sun. This can often provide interesting results and good ideas for future subjects (see left).

7
Gallery

Afterglow on Moose Marsh
Dale Meyers
23½ × 30in (59.7 × 76.2cm).
Dale Meyers is based in New York, has exhibited widely in the USA, UK, France, Italy, Poland, Australia, Japan and Russia, and is First Vice President of the American Watercolour Society.

This atmospheric watercolour is one of a series planned as a compliment to the forces of the environmental movement and was inspired by the landscape beauty of Moose Marsh in the Adirondack mountains in New York State. Dale comments that she prefers the intimate view of a segment or slice of life rather than the vast landscape, as is demonstrated by this superbly executed watercolour.

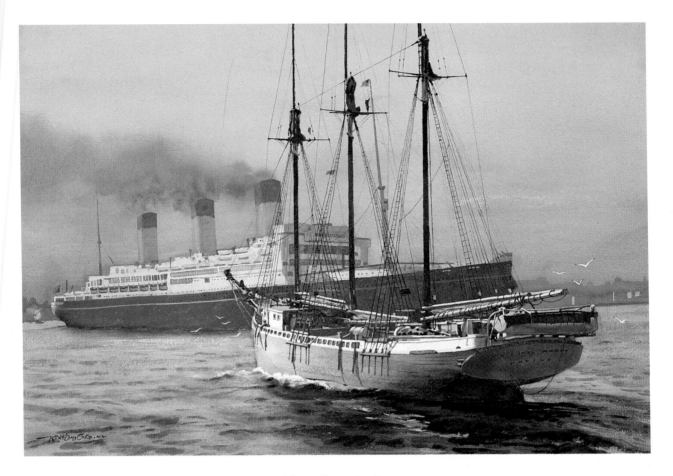

Home from the Sea
Kent Day Coes
20½ × 28½in (52 × 72.4cm).

The scene of this evocative painting is New York Harbour about 1935. The steamer is the RMS Majestic outbound for Cherbourg, the smaller vessel is a coastal schooner which has come up the Atlantic Coast. Kent Day Coes created this superb marine watercolour from old photographs he took at the time, which he recently rediscovered. A member of the American Watercolour Society, Kent Day Coes was a founder member of the New Jersey Watercolour Society, and began exhibiting watercolours while still at art school. He has exhibited widely and his work is in the permanent collections of art museums and in industrial, university and private collections. He lives in Upper Montclair, New Jersey.

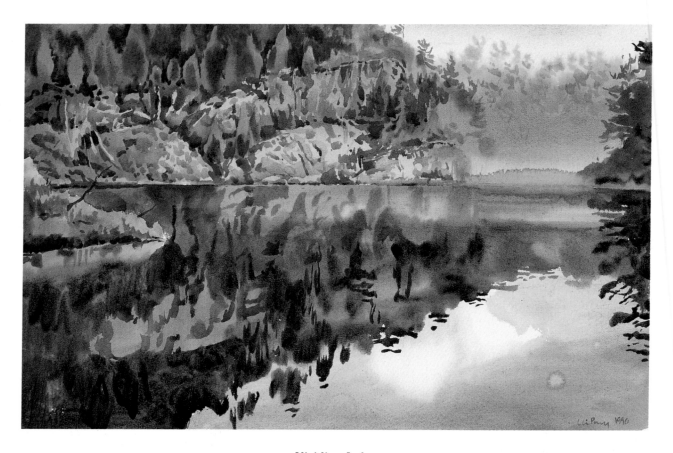

Viridian Lake
Clive Powsey
22 × 30in (56 × 76cm).

*Clive Powsey spends much of his time paddling his canoe across
the wilderness waters of Northern Ontario as part of an
environmental project. Using 140lb Arches paper he has
worked the wet paint to create a feeling of depth and calm in
this northern lake. Clive is a member of the Canadian Society
of Painters in Watercolours and has exhibited widely across
Canada. He lives in Bowmanville, Ontario.*

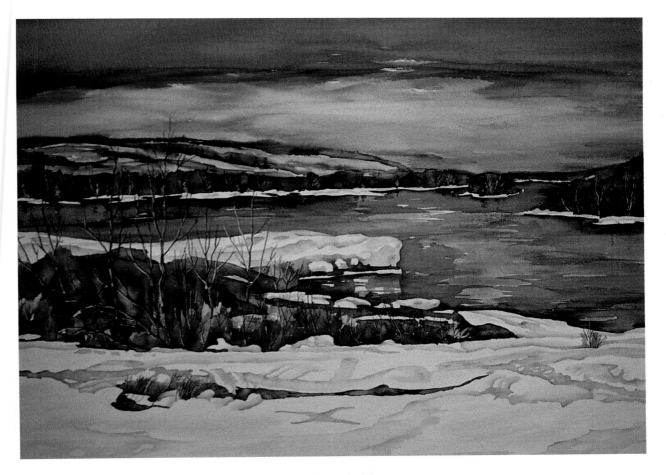

Break Up
Adeline Rockett
22½ × 30in (57 × 76cm).
*Based in Edmonton, Alberta, Adeline Rockett is a member of
the Canadian Society of Painters in Watercolour and has
exhibited extensively in Canada as well as in the USA,
England, Japan and Thailand. Inspired by the northern winter
landscape, this painting is one of a series using the same title.
It vividly captures the atmosphere and character of northern
Canada, using colour and composition to emphasise the cold
loneliness of the landscape. Adeline's interest in depicting
winter scenes is evidenced by the title of some of her solo
exhibitions: Winter Frieze Series, Spring Thaw, and Arctic
Impressions.*

Index